RICHMOND UPON THAMES
THROUGH TIME
Paul Howard Lang

AMBERLEY

First published 2015

Amberley Publishing
The Hill, Stroud, Gloucestershire, GL5 4EP
www.amberley-books.com

Copyright © Paul Howard Lang, 2015

The right of Paul Howard Lang to be identified as the
Author of this work has been asserted in accordance with
the Copyrights, Designs and Patents Act 1988.

ISBN 978 1 4456 3923 9 (print)
ISBN 978 1 4456 3934 5 (ebook)

British Library Cataloguing in Publication Data.
A catalogue record for this book is available from the
British Library.

Typesetting by Amberley Publishing.
Printed in Great Britain.

Introduction

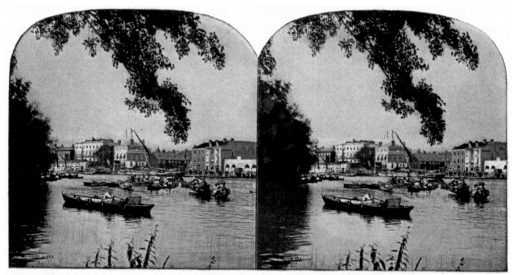

Richmond, England.

Rare stereoscopic image of Richmond, during the 1890s. This shows the White Cross Inn at the centre of the image on Richmond bank, and St Helena Terrace boathouses can be seen on the left, as can the end of Corporation Island. Redknap boathouses, now demolished, can be seen on the right-hand side

This book shows ninety matching images, the majority of the older pictures having been taken from Edwardian postcards. The modern photographs show how the places have changed. The book also depicts eight original photographs never before published. The earliest and possibly most interesting being the Victorian image of the main gate at Kew Gardens. The picture of the previous theatre in Richmond came from an early theatre programme dating to 1891.

The images have been ordered as if taking a sequence of walking tours of the area, starting with Richmond Bridge, which is the only surviving Georgian bridge over the river Thames. The illustrations start with the bridge as most people know this iconic landmark. The pictures have been collated from my collection to show different landmarks along the river, going towards Petersham, and then reversing direction and finishing at the lock bridge. Richmond is the only London borough spanning both sides of the Thames, with just over twenty-one miles of river frontage. The next section of Richmond to be dealt with are the main streets, starting with George Street and extending as far as Sheen Park. Buildings of architectural note are then grouped, with the remains of the old palace starting this section off. Last to be featured comes a series of images devoted to open spaces, Richmond Green taking the lead.

Just to say a little about Richmond itself, before moving on to the other areas that comprise Richmond upon Thames. Richmond is an outer London borough located in south-west London. Hounslow, Hammersmith & Fulham, Wandsworth and Kingston all border Richmond. Looking back over the rich tapestry of Richmond's history, certain pivotal developments stand out as

defining moments in Richmond's rise to economic and social prestige. It is to Henry VII we owe the change of name from Sheen to Richmond, as he named his palace after his esteemed Yorkshire property. It was the Royal palace at Richmond that finally put the district on the map. Where monarchy goes, the aristocracy tends to follow and this in turn made the area a desirable one. Sadly little is left of the original palace, but it was a vast and imposing structure dominating the whole area. The same can be said for its two main religious institutions, the Sheen Charterhouse, a Carthusian monastery which flourished until the reformation, and the Observant Franciscan Friary, dissolved around 1534. However the pattern had been set and Richmond was perceived as an area of Royal and ecclesiastical patronage, thus further attracting important people to the area.

Richmond came under Kingston upon Thames up to 1849, when Richmond became a parish in its own right. Richmond's incorporation by Royal Charter came in 1890 when its status changed to a borough. It was the river Thames that made Richmond such an economically viable area. When roads were rough, poorly constructed affairs, goods could be more easily transported by river. Lightermen and watermen flourished along the river, the boathouses at St Helena Terrace being a testament to this.

Brewing became an important industry in eighteenth-century Richmond, the chief example being the Downs/Collins brewery situated in Water Lane. Mortlake was also an area where brewing was an important industry. Another impetus to Richmond's development came when a chalybeate spring was discovered around 1675. Eventually a medicinal spa developed, which made Richmond a fashionable place to visit, unfortunately this did not last long, but attracted many people while the craze lasted.

As regards transport, steam boats had brought sightseers to Richmond, but the advent of the railway in 1846 brought hordes of visitors to the area, fostering a boom in retail establishments of all kinds, thus bringing prosperity to the town. Many other factors were instrumental in making Richmond such an important place. Not only the aristocracy, but some notable literary figures had links to Richmond. The one that immediately springs to mind, being Charles Dickens, who regularly invited his friends to celebratory functions at the Star & Garter; Virginia and Leonard Woolf set up a printing press in Paradise Road (the Hogarth Press); George Eliot also lived for a time at Parkshot. Another seasonal visitor was William Makepeace Thackeray, who stayed at Rose Cottage in Richmond.

South of Richmond is Petersham being the next area given attention, as it is so intimately connected with Richmond. Ham and Petersham are also both strongly linked, so Ham is the next area, radiating outwards. Looking north-east of Richmond, Kew is the next area as in the Victorian era, a part of what we think of as Kew, was at that time part of Richmond. An Ordnance Survey map published in 1868 shows the Richmond boundary extended along the Kew Road to just beyond the Temperate House in Kew Gardens. The Royal Botanical Gardens are of extreme importance in attracting visitors from far afield to the area and are of world renown.

To the east of Richmond lay the parishes of East Sheen, Mortlake and Barnes lay. Mortlake has strong historical associations with Dr John Dee; Barnes has musical associations with Gustav Holst; and the famous church architect Sir Arthur Blomfield lived in East Sheen, and these are just a few of the many famous people who lived in these parishes.

Marist Convent, Queen's Road, Richmond, 1905. This image highlights how rural Richmond was at this period.

It will be noted that the Hamptons, St Margaret's, Teddington, Twickenham and Whitton have been omitted in this book. This is because two books already cover these areas, both published by Amberley Publishing, notably *Twickenham, Whitton, Teddington and The Hamptons Through Time* by Mike Cherry, John Sheaf, Ken Howe and Ed Harris, and *Teddington, Kingston & Twickenham: An Illustrated Walk*, by Garth Groombridge.

Although some of the views in this book may be familiar to the reader, I am sure that others will be completely new, for example the superb image of Pitt's restaurant in Kew, or the coronation celebrations of 1911 in Ham. As regards to further reading on the history of Richmond, I would strongly recommend John Cloake's *Richmond Past* and Janet Dunbar's *A Prospect of Richmond*. As to criminal activity in the area, Jonathan Oates book *Foul Deeds In Richmond & Kingston gives* a good account. My favourite antiquarian book on Richmond is Richard Crisp's *Richmond and Its Inhabitants from the Olden Times*, published in 1866. Richard Crisp is buried in Petersham churchyard, along with many other notable persons.

A notable change in the borough is the redevelopment of the Star and Garter Home following the departure of its former residents. The other building undergoing conversion is the former Richmond Brewery Stores (dating to June 1908) along the Petersham Road, which is being converted to luxury apartments.

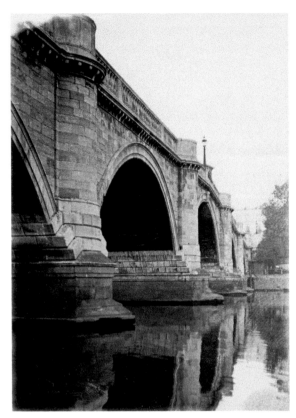

Richmond Bridge

Of all the bridges crossing the Thames, Richmond Bridge is the oldest, dating back to 1777, and I think the most aesthetically pleasing of them all. The architect was James Paine (1717–89) who also designed Walton and Kew bridges, although both of these have now been superseded by modern structures. Richmond Bridge has five well-proportioned arches and is faced with Portland stone. Tontine shares were raised to help finance the building and maintenance of the bridge, and it only became toll-free after the last person owning these tontine shares died, and that was not until 1859.

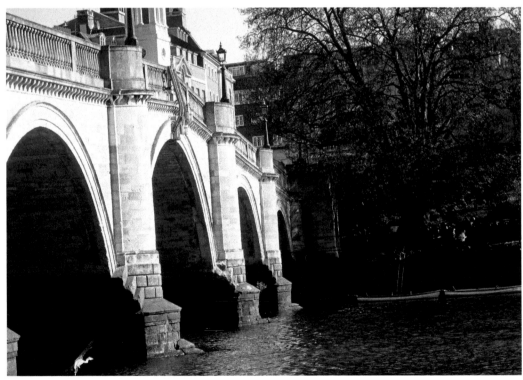

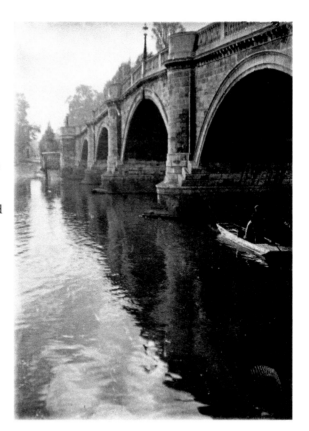

Man Fishing Under Richmond Bridge
Fishing at Richmond was very popular in the Victorian and Edwardian periods. In 1901 it was said that barbel, dace and gudgeon were plentiful in the Thames at Richmond. Cholmondeley Walk was favoured by bank anglers at this time, but near Richmond Bridge, skiffs, punts or boats definitely helped the angler as fishing lines were less likely to get ensnared by other passing boats. It must also be remembered that the local hostelries, particularly those sited along the riverbanks, such as the White Cross, benefitted greatly from the patronage of the angling fraternity.

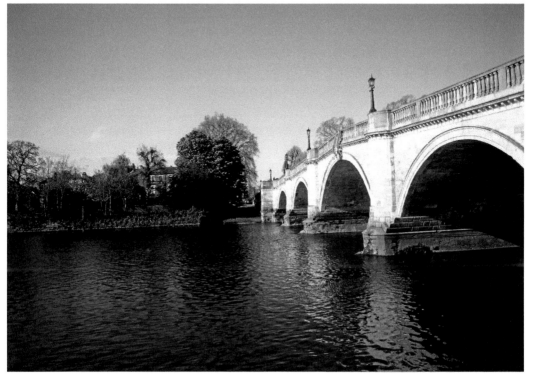

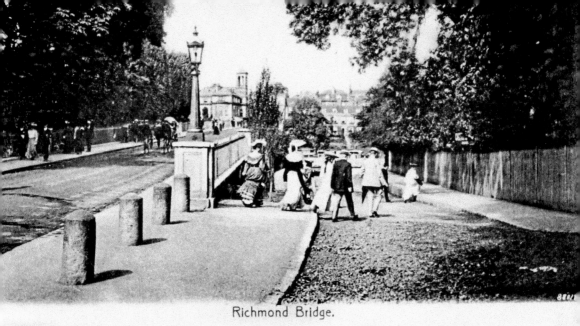

Richmond Bridge.

Richmond Bridge

This image shows Richmond Bridge taken from the Twickenham side, and graphically depicts the flow of pedestrian traffic between these two areas. It also demonstrates how popular perambulations along the riverbank were during the Edwardian period. The tower on the left hand side across the bridge is Tower House, dating to 1856. In 1907, the date this image was taken, Mr Street, LDS, RCS, a dental surgeon resided at Tower House. His surgery was at No. 1 Heron Court in Richmond. The Edwardian image also demonstrates how fashionable cycling was at this period. Walks along the river are still popular now.

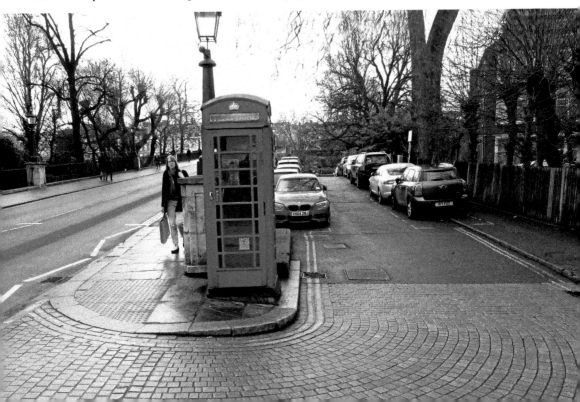

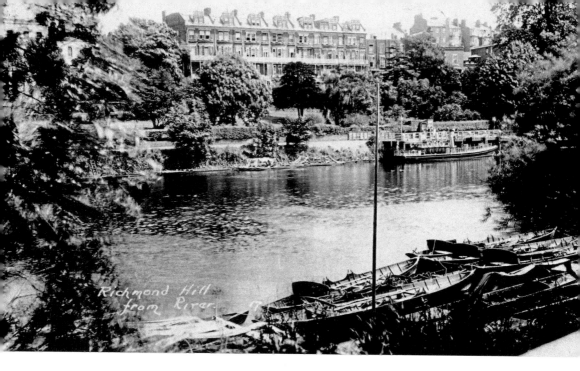

Richmond Hill from the River

A beautiful view of the river Thames and the landing stage not far from Richmond Bridge taken in 1935. The row of buildings on the opposite side of the river was known as Camborne Terrace, named after Camborne House that had been demolished. A regular steamboat service operated in the summer months in the 1930s. The first steamer that ran between London and Richmond was in 1814 and was called the 'Richmond'. In 1817 the 'Richmond's' boiler burst, a hazard of these early steamers. All looks calm and tranquil in the modern photograph.

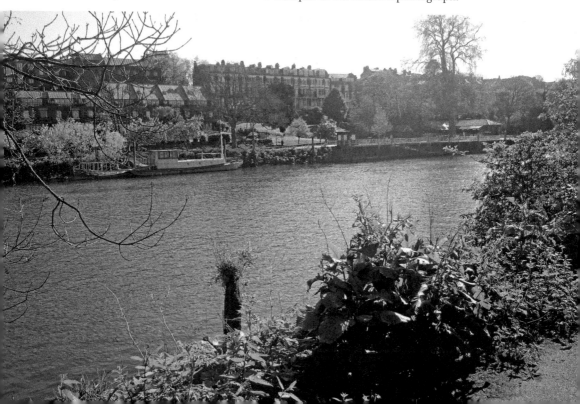

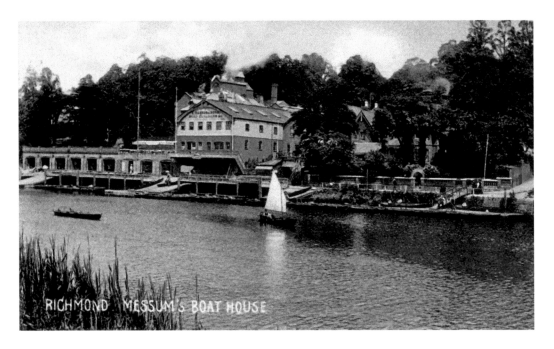

Messum's Boat House, Richmond

Messum's boat house is pictured here in 1907. The business was founded by Mr Richard Henry Messum and started from the Lansdowne boathouse. He pioneered a new type of skiff, which was much more manoeuvrable than the Thames wherry. In 1901 the boathouses and the Pigeon's Hotel suffered a bad fire. His two sons took over the business and successfully ran it for many years. The firm produced boats for Royalty and even exported boats. In the modern photograph you can see that the Richmond Canoe Club now occupies parts of the former boathouse.

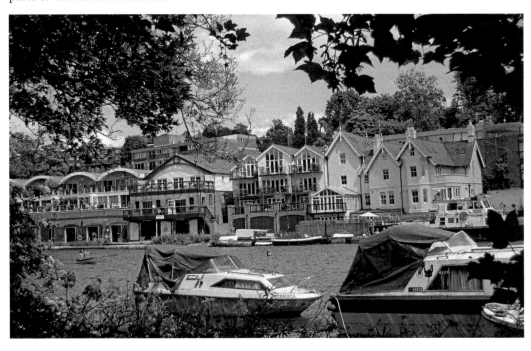

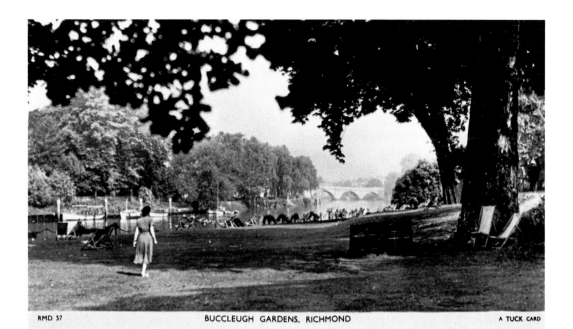

Buccleugh Gardens, Richmond.

Buccleugh Gardens pictured here in the 1950s shows what an ideal spot this was for the public to hire a deckchair and peruse this tranquil river scene. Buccleugh House, from which the gardens derives its name, was demolished in 1937. One of the most interesting parts of the gardens are the subways that run underneath the Petersham Road, and link Buccleugh Gardens with Terrace Gardens. Three mansions once stood in these gardens, Buccleugh, Lansdowne and Cardigan, although the houses have all gone, fortunately the gardens have been preserved for public use.

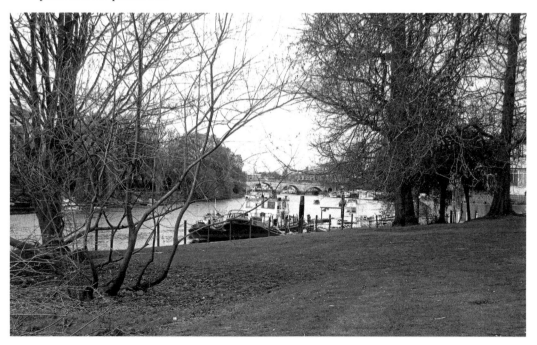

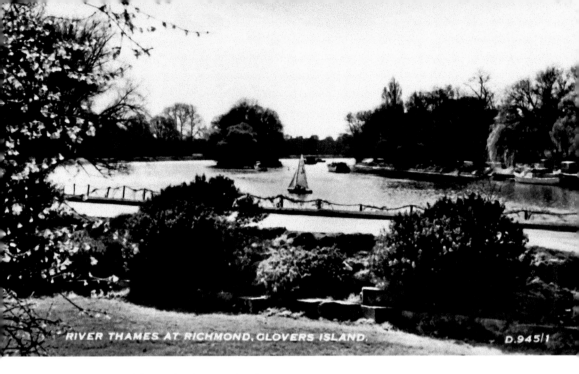

RIVER THAMES AT RICHMOND, GLOVERS ISLAND. D.945/1

River Thames at Richmond, Glovers Island.

Glovers Island is one of the distinguishing river features in Richmond, here viewed from Buccleugh Gardens. The island is relatively small in size, but has an interesting history. It was first called Petersham Ait, but was purchased for a nominal sum in 1872 by Joseph Glover. When he sold it there was great concern that there was an intention to build club like facilities on the island. The island was bought by Mr Max Waechter, DL, JP, who generously gave the island to the town council in 1900. The island does not stand out as clearly as it does in the older view.

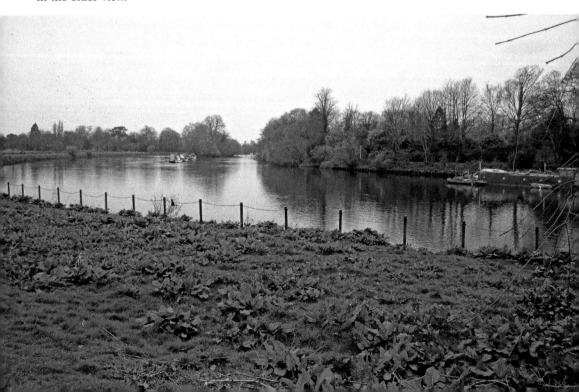

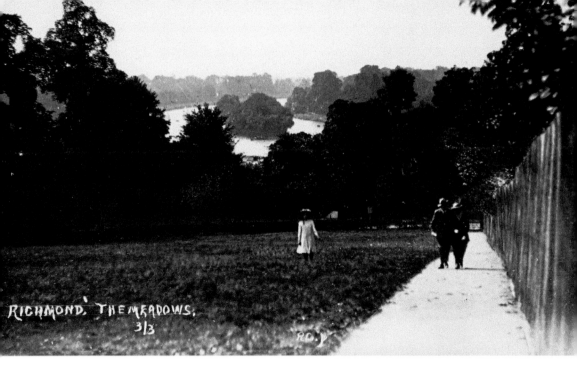

The Meadows

The Petersham meadows looking towards Richmond comprises thirty acres of grassland. Glovers Island can clearly be seen in the middle of the Thames. Although now open, note that the area on the right has been fenced off. The view from Richmond Hill which incorporated the meadows was protected by the first 'environmental' Act of Parliament in 1902, as it was feared that houses would have been built on this land. Petersham meadows are still used to graze cattle, and it is a wondrous sight to see such a rural scene only ten miles from Central London.

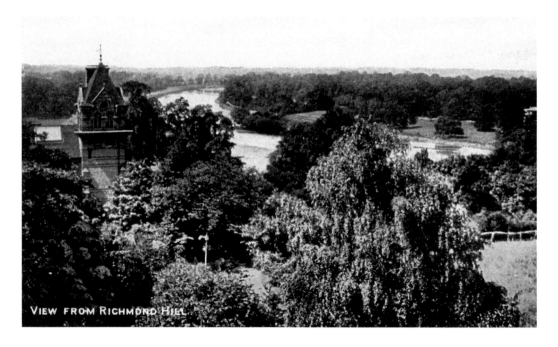

VIEW FROM RICHMOND HILL.

View from Richmond Hill

The view from Richmond Hill of the river Thames is famous for its sweeping vista of unspoilt beauty. The building on the left is currently named the Petersham Hotel, although first called Nightingale Hall, and was built in 1864. In 1865 it was named the Richmond Hill Hotel, then in 1924 it became the New Star & Garter; in 1978 The Mansion; and finally in 1987 the Petersham Hotel. The building has over sixty bedrooms and commands outstanding views over the Thames.

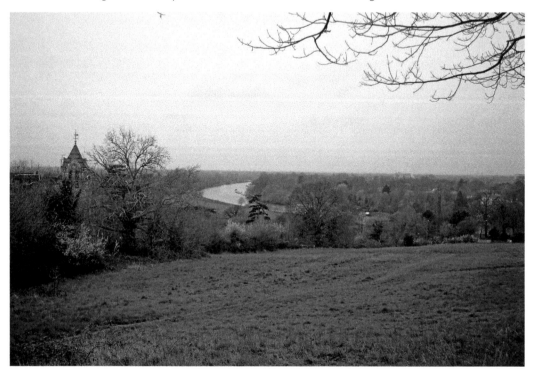

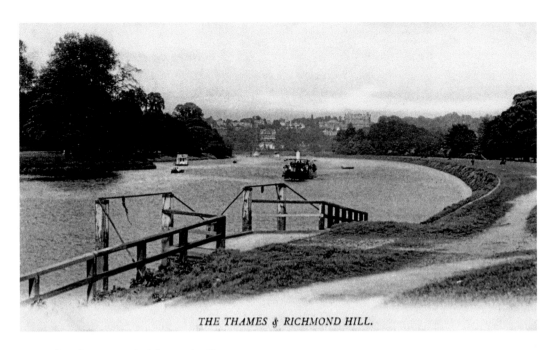

THE THAMES & RICHMOND HILL.

The Thames and Richmond Hill

In the Edwardian picture we see the steamer leaving Richmond and cruising past Petersham, taken around 1909. In that year the steam-launch *Duke of York* used to leave Richmond pier daily at 11 a.m. for Staines, returning at 7 p.m. On Sundays a number of steam and electric launches would make frequent upriver trips to Hampton Court, Teddington Lock and other places. A saloon steamer would leave London Bridge daily at 10 a.m., arriving at Richmond around 12:30 p.m. although this would be dependent on the tide. In the modern view two passenger boats can be seen continuing this service.

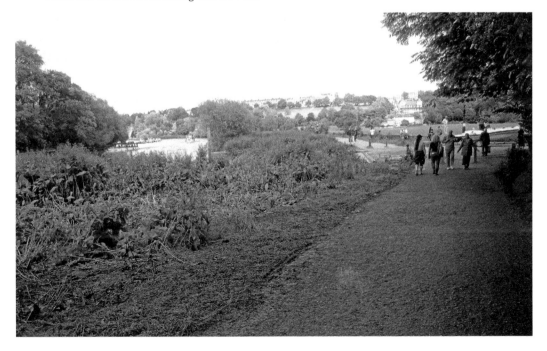

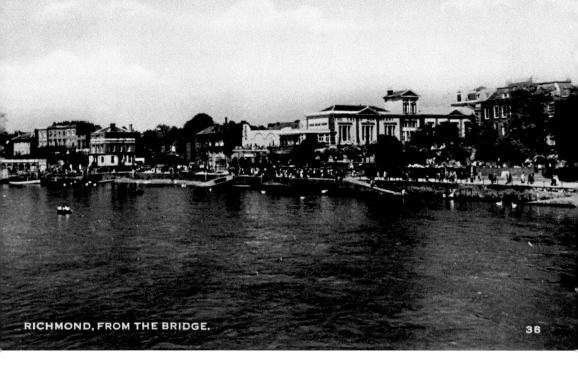

RICHMOND, FROM THE BRIDGE. 38

Richmond from the Bridge

This panoramic view was taken in 1956 from Richmond Bridge extending as far as St Helena boathouses on the left-hand side. The most dominant building is the former Castle Assembly Rooms. The Castle Restaurant sign can clearly be seen on this building. The restaurant measured approximately 72 feet by 35 feet, and was capable of seating 500 persons; it had a central oval dance floor. In the modern photograph the Quinlan Terry riverside development completed in 1988 has transformed the area on the right-hand side.

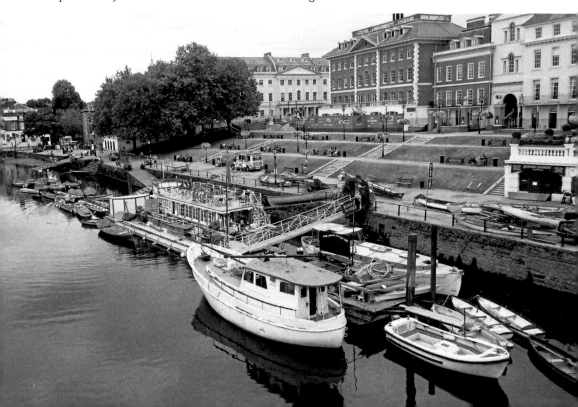

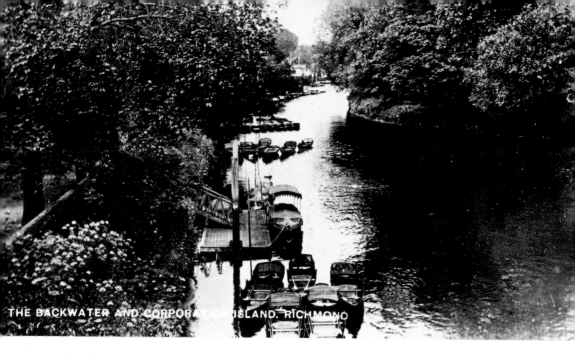

THE BACKWATER AND CORPORATION ISLAND, RICHMOND

The Backwater and Corporation Island, Richmond

Corporation Island stands 350 yards downstream from Richmond Bridge, nearer to the Twickenham bank than the Richmond side. The image shows how heavily wooded the island was, although in 1960 the council approved the felling of the plane trees on the island. However, the island was soon replanted with weeping willows around the island's perimeter and swamp cypress trees in the centre. In all sixty trees were replanted. Today we can see that it has returned to its wooded state.

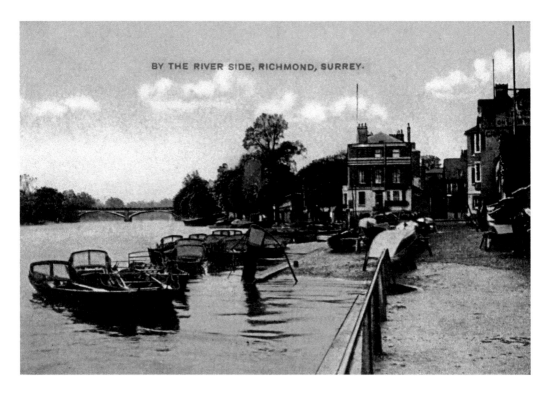

BY THE RIVER SIDE, RICHMOND, SURREY.

By the River Side, Richmond

The White Cross public house (which can be seen in this view, just off-centre on the right) can be dated back to around 1728. It was originally called the Waterman's Arms. There is much debate concerning the name White Cross, but it probably relates to the name of the licensee Samuel Cross, or possibly his sister-in-law Ann Cross. However, some think that the name derives from the proximity of the ancient religious establishment, the Convent of Observant Friars, that once stood close by Richmond Green. The riverside location of the 'White Cross' has been attractive and popular up to the present day.

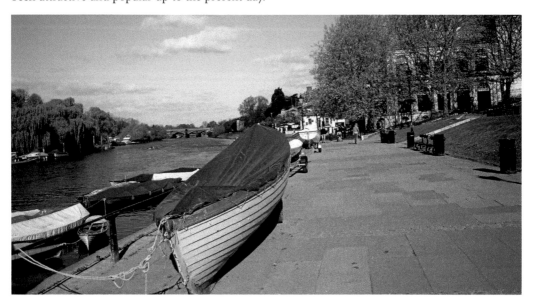

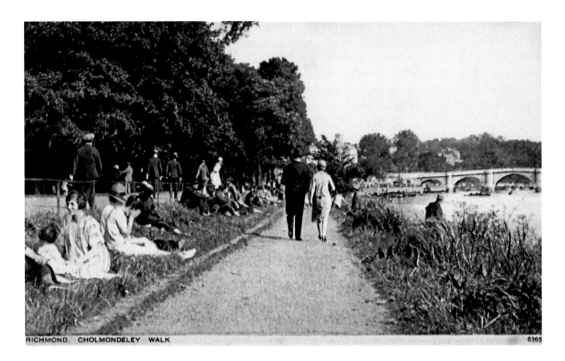

RICHMOND. CHOLMONDELEY WALK 6365

Cholmondeley Walk, Richmond

Although now a pleasant spot to walk along, it must be remembered that the public did not always have access to the banks of the riverside. It was not till 1774 that the embankment from Kew to Cholmondeley Walk was completed, until that date the towing path ended opposite Isleworth. The Duke of Queensbury who owned Cholmondeley House tried to extend his grounds by taking in Cholmondeley Walk. The locals greatly resented this and subsequently took legal action and fortunately the law upheld the right of the public to have access to this fine riverside walk.

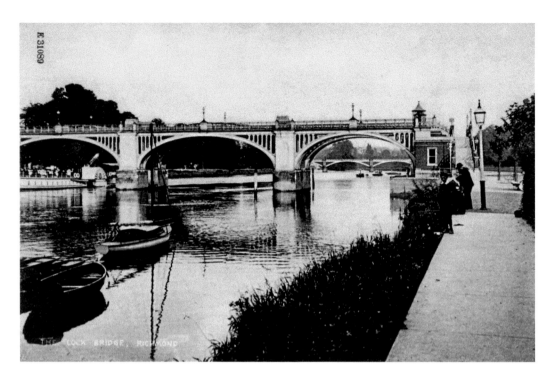

The Lock Bridge, Richmond

This magnificent piece of Victorian engineering dates to 1894. The footbridge and weir was opened on 19 May 1894 by the Duke of York, the future King George V. Income for the bridge and lock was generated from a toll for foot passengers, the fee being one penny each way (postmen and soldiers were exempt from the toll). This toll ceased in 1939. The toll house can still be seen, as can the turnstile mechanism.

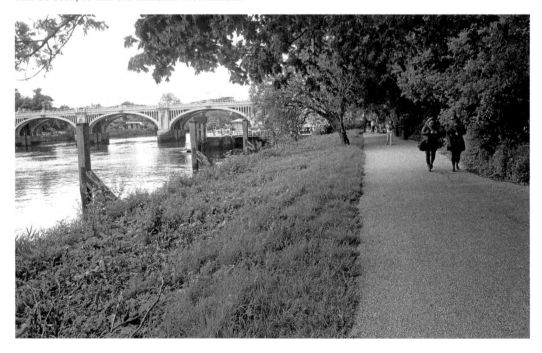

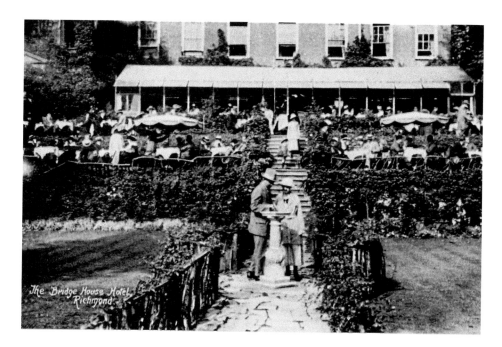

The Bridge House Hotel

This image of the grounds and upper terraces of the Bridge House Hotel dates to 1920. The house dates back to 1704, only later on was it renamed Bridge House, almost certainly after the bridge itself had been erected across the Thames in 1777. One of its early inhabitants was Moses de Medina, a rich Jewish merchant adventurer in the East India Company, who lived in this house from 1721 until his death in 1731. Two members of the clergy also lived in this house, Abielle Borfett and the Revd Tilson. Bridge House was demolished before the 1960s, and only the gardens remain next to the bridge on the Petersham side.

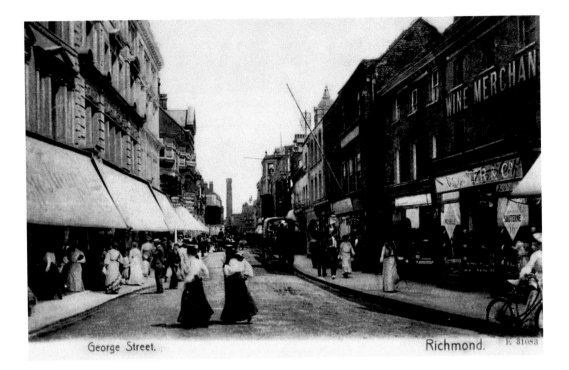

George Street. Richmond. E. 31083

George Street

This image captures the hustle and bustle of the Edwardian period. Women are eagerly shopping and it clearly demonstrates how popular Gosling and Sons Ltd drapers store on the left was at this time. On the eastern side of George Street was wine merchants T. Foster & Co, next to that a confectioners owned by George Settree, then another wine merchants, owned by George Henry Young. After that came the superbly named British & Foreign Fancy Stores and then a barber, butcher and a tea dealer. The modern view sadly does not have the vibrancy and overall intrigue of the Edwardian image.

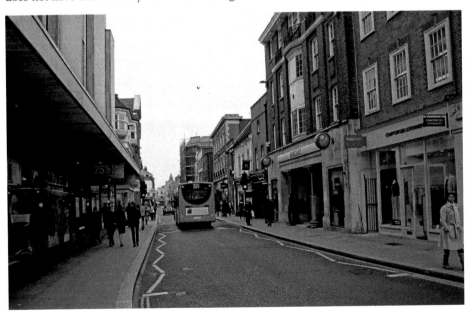

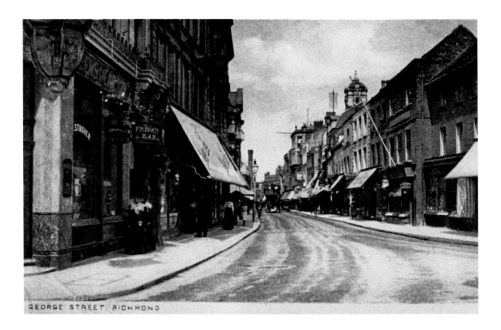

George Street

Here we see George Street from the corner of King Street looking towards Kew, around about 1919. The prominent building on the left hand corner was the Queen's Head Hotel, the landlord being Mr Herbert Pinn. This building was eventually demolished in 1968. Just beyond the Queen's Head was the famous drapers store Gosling and Sons Ltd, which in time expanded to fill the whole of this corner area and became quite a distinguished department store. The House of Fraser now stands on this corner site, and all the charming old shops have been replaced.

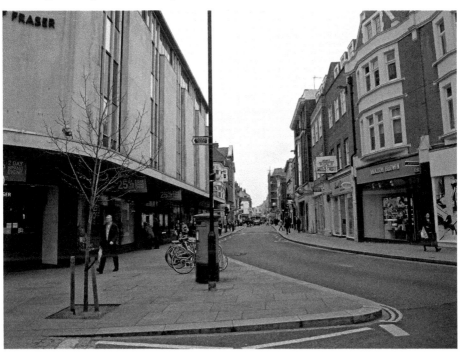

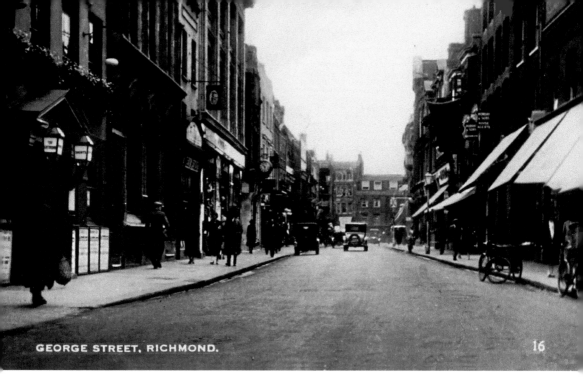

George Street, Showing the Greyhound

George Street is pictured here looking towards Hill Street. On the left-hand side can be seen The Greyhound public house. The tavern dates back to 1703 and was originally called the White Horse. During the Victorian period it was one of Richmond's premier hotels. It closed in 1923. Notice the notice boards at pavement level all along the front of the building. Auctions were regularly held at The Greyhound and details of such were posted on these notice boards outside.

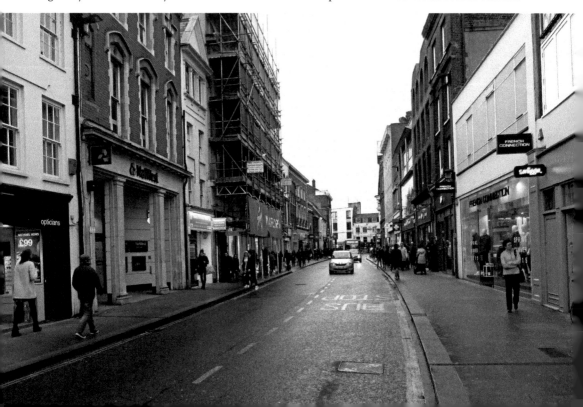

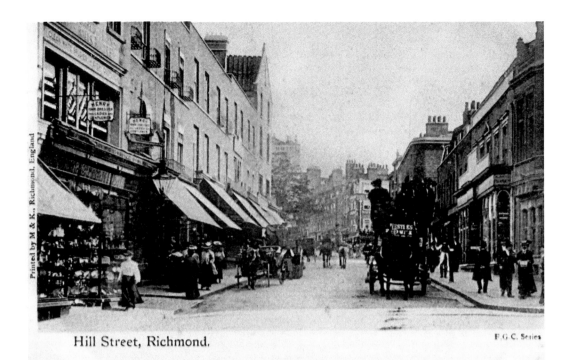

Hill Street, Richmond.

F.G.C. Series

Printed by M & K., Richmond, England

Hill Street, Richmond

A view of Hill Street dating to 1905, looking towards the Petersham Road. The china store on the left, below the sign for John Henry, hairdressers, was owned by G. Whetman and Son. After Castle Yard came Hiscoke and Son, Booksellers, Printers, Stationers and Newsagents. Beyond this block the word Hotel can just be made out at the top of the building; this was the Talbot Hotel, which dates back to the 1740s. The scene shows what a busy shopping area Hill Street was in this period. The modern photograph shows how bland the current shops look in comparison to the Edwardian scene.

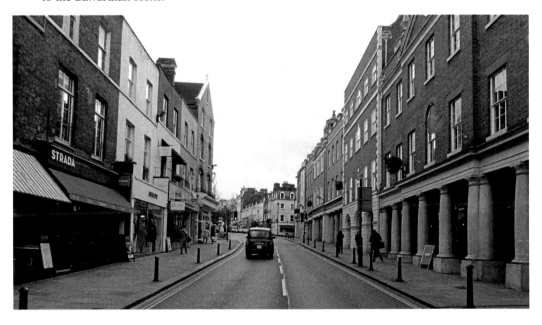

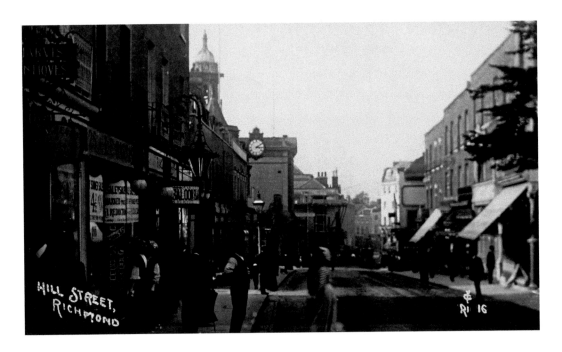

Hill Street

An incredible amount of detail regarding the shops can be seen on the left-hand side of this image, dating to 1913. The sign that can be seen for Jarvis Antiques relates to John Henry Jarvis' shop, described as a curiosity dealer. The luncheons and afternoon teas sign belonged to the Royal Caven Tea Rooms. A selection of postcards for sale can be seen in the next shop. Then there was a fishmonger, Mr Walter Obee, and then the Royal Arms public house, the landlord being Mr Harris. Just before Heron Court was a cigarette manufacturer, owned by the intriguingly named Mr Stratiades.

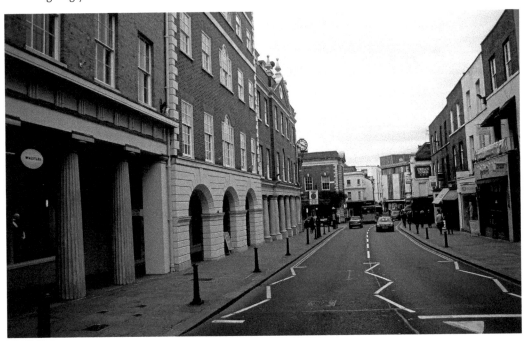

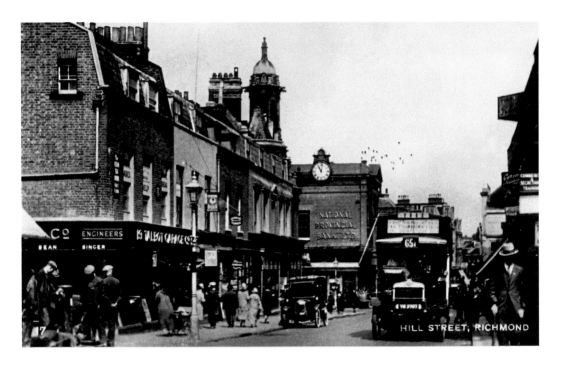

Hill Street in the 1940s

A rare view of Hill Street in the 1940s, just after the Second World War, showing that a diversity of shops existed then. Mr A. Hoskins was the manager of the National Provincial Bank on the left. At the town hall, the town clerk during this period was Mr Clifford Heyworth. The Talbot Garage was named after the Talbot Hotel that stood on the opposite side of the road from about 1740 to 1914. The modern photo shows the redevelopment of the area, the only constant being the No. 65 bus that still takes this route.

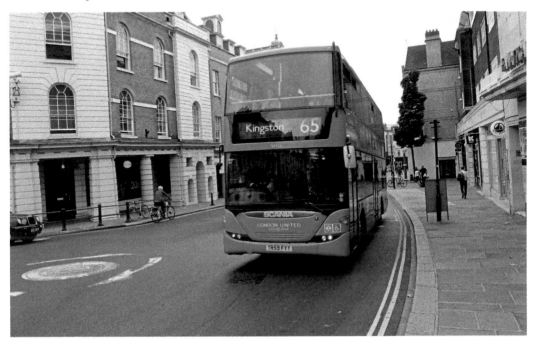

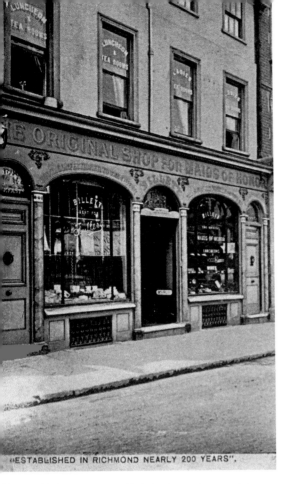

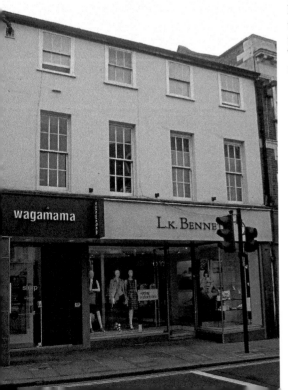

The Original Shop for Maids of Honour, Richmond

This shop stood in Hill Street opposite Red Lion Street. The original owner of the shop was John Billet. The establishment on the Kew Road has now become the most popularly known. This was started by Alfred Nashbar Newens, the son of Robert Newens who had been apprenticed in the Hill Street shop. Maids of Honour were a type of jam tart, thought to have originated in the Royal kitchens at Hampton Court. The recipe for the tarts is a closely kept family secret to this day. The current photograph shows that The Original Shop for Maids of Honour is now Wagamama and L.K. Bennett.

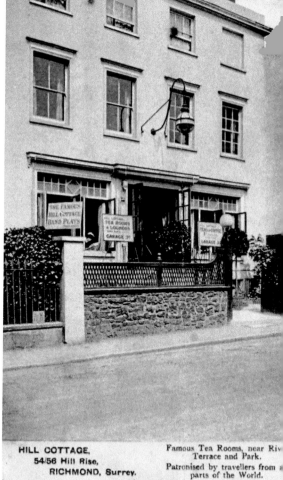

Hill Cottage

Initially a private residence, Hill Cottage dates to 1786. In 1901 a building with a parquet dance floor was erected on the site which became Hill Cottage Tea Rooms and Lounges. An early advertisement states: Hill Cottage – Teas 1s – inclusive – Garage 3d – Band Plays. The tea rooms became a popular venue in the 1920s. In the 1930s a building was erected behind the shop which acted as a shadow factory during the Second World War, manufacturing parts for Spitfires. In the 1950s this became a doll's factory and then a printers. In the 1960s the shop sold modern furniture. In the modern photograph we can see that it is now Boa boutique.

HILL COTTAGE,
54/56 Hill Rise,
RICHMOND, Surrey.

Famous Tea Rooms, near Riv
Terrace and Park.
Patronised by travellers from a
parts of the World.

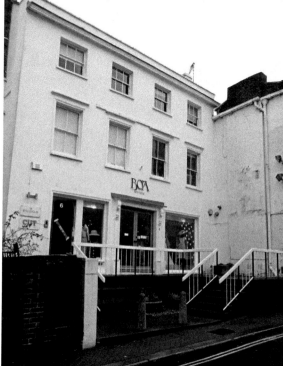

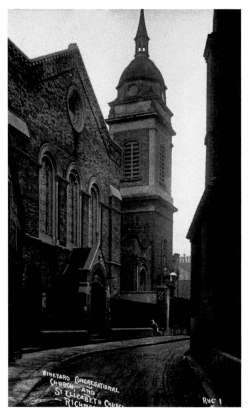

Vineyard Congregational Church and St Elizabeth Church

This Edwardian view of the Vineyard shows the two churches, side by side along this historic part of Richmond. The Congregational church on the left opened in 1830; unfortunately the original chapel burnt down in 1851 and was rebuilt and opened on 6 April 1853. The architect was John Davies and it was built in a Norman style. St Elizabeth church in the centre of the picture is dedicated to St Elizabeth of Portugal, and is a very old (built 1824) Catholic church. The foundress was Miss Elizabeth Doughty. The interior of this church is an absolute jewel and well worth a visit.

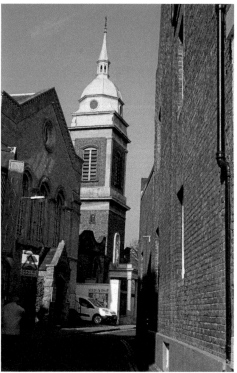

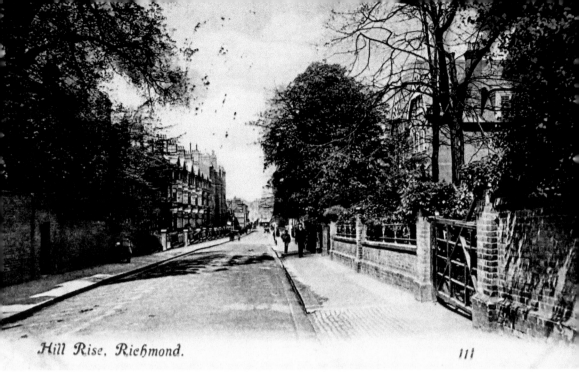

Hill Rise, Richmond. 111

Hill Rise, Richmond

This coloured view of Hill Rise has been taken from further up Richmond Hill from beyond Ellerker Gardens, looking down at the shops in the distance. Hill Rise is defined as that section of the road from Ormond Road to The Vineyard. Hill Rise came into being as the lower road (now the Petersham Road) was often impassable in inclement weather, so a higher causeway was constructed to overcome this problem.

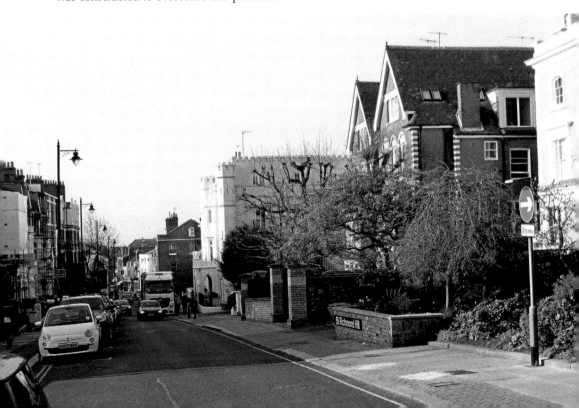

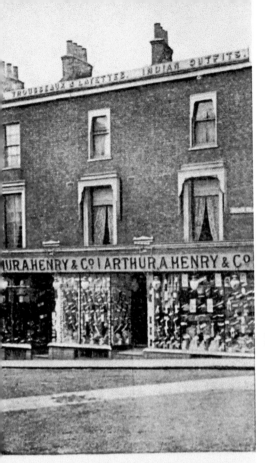

Business Premises, *A. Henry & Co., Drapers, Milliners & Outfitters, 1, 2, & 3 Bridge Street, Richmond.*

Arthur Henry & Co., Bridge Street

The Arthur Henry & Co. shop was described in local directories as 'fancy drapers and milliners and railway agents'. The image dates to 1910. The person who owned the shop was Mr Joseph Till, he just traded under the name of Arthur Henry & Co. He occupied this site from 1904 up to 1910. Prior to 1904 it had still been a fancy draper and milliner shop, but then owned by Mr J. Prior Legge. Next door to Arthur Henry at number four further down the hill was Gaynor & Son, sporting goods stores, selling fishing tackle. The current photograph shows that this entire block has been redeveloped and is now the Cedar Coffee Shop.

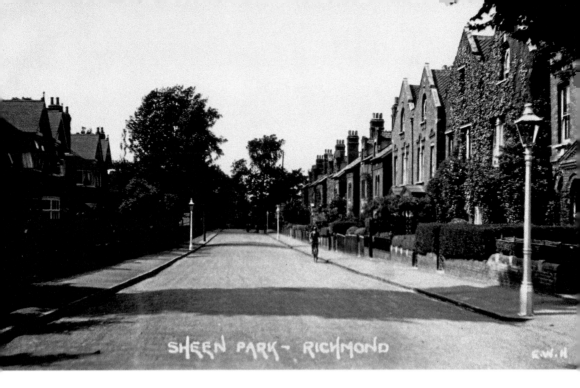

SHEEN PARK - RICHMOND

E.W.H

Sheen Park

In an article dated 1912, entitled 'Richmond 50 Years Ago', Sheen Park was described as 'a secluded pleasaunce crowded with fine timber trees and flowering shrubs, then in the possession of Sir Harry Baker'. It goes on to say, 'just beyond Sheen Park at the corner, were several low, quaint, old cottages, with long gardens'. Unfortunately the trees have long gone, and a mixture of buildings of different periods has taken their place. The layout of the road in the form of a square was completed in 1870 and was developed by John Maxwell.

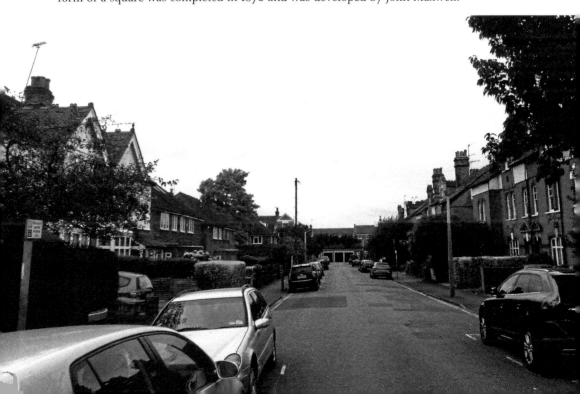

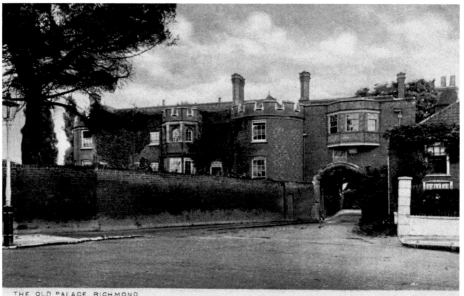

THE OLD PALACE, RICHMOND

The Old Palace, Richmond

The gateway to the old Tudor palace at Richmond, and the buildings on the left of the courtyard, known as Wardrobe Court, are sadly all that remain of this once 10 acre site, formerly covered with palace buildings. Over the archway can be seen the stone escutcheon of Henry VII. It was this king who rebuilt the palace and changed the name from Sheen to Richmond. The first palace at Richmond on this site goes back to the reign of Edward III. Many other monarchs lived at the palace and Cardinal Wolsey, after relinquishing Hampton Court palace to Henry VIII, resided at Richmond Palace. In the modern photograph you will see that the oriel window over the archway has now entirely disappeared.

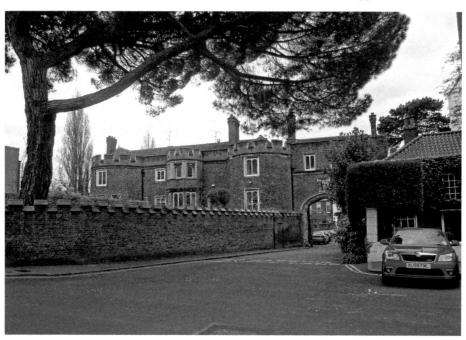

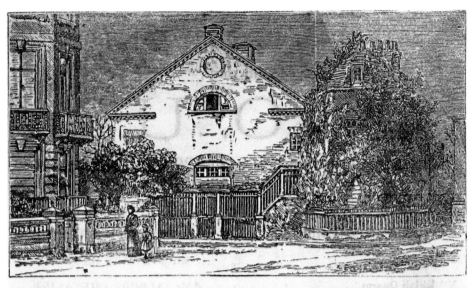

OLD RICHMOND THEATRE & EDMUND KEAN'S HOUSE, pulled down in 1884.

Old Richmond Theatre

The Theatre Royal can be seen in the centre of the picture, Wentworth House is on the left and Edmund Kean's house just to the right of the theatre. The theatre stood near to the top of Old Palace Lane on the Green, and was opened on the 15 July 1765; the first production was *Love in a Village*. Edmund Kean, the famous actor, performed here, as did Sarah Siddons, William Macready and Mrs Jordan. The manager's name was James Dance. The theatre lasted till 1884, and in the modern photograph the houses in Garrick Close can now be seen where the theatre once stood.

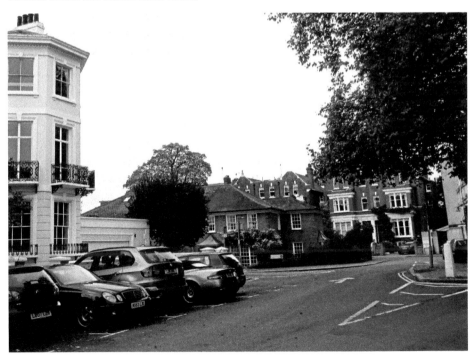

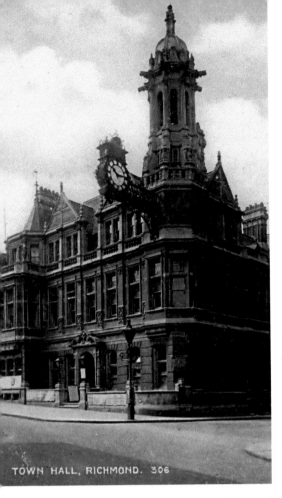

TOWN HALL, RICHMOND. 306

Richmond Town Hall

The architect of the town hall was William James Ancell (1852–1913). Richmond received its borough charter in 1890, John Whittaker Ellis being the charter mayor. The town hall building was opened on 10 June 1893 by HRH Prince George, Duke of York. The building suffered badly during the Second World War, when incendiary bombs destroyed the roof and the council chamber. The building was restored in 1952. In 1965 it became the main offices of the Social Services Department. The museum which is in the old town hall building opened in 1988.

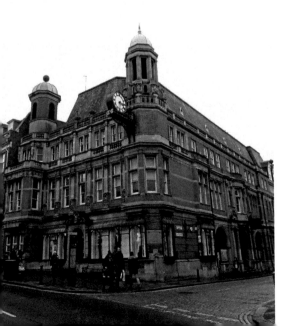

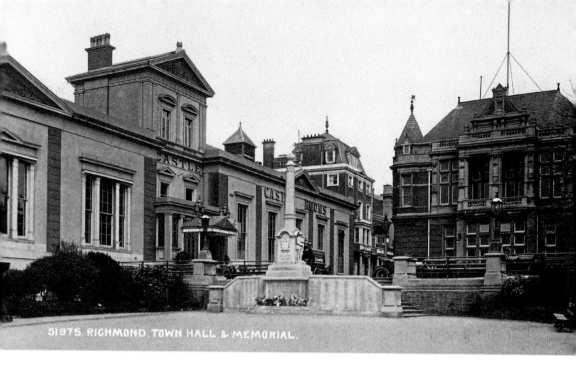

51975. RICHMOND. TOWN HALL & MEMORIAL.

Richmond Town Hall and Memorial (and Castle Rooms)

Richmond Town Hall seen here from the river frontage side, the war memorial and Castle Assembly Rooms can also be seen on the left. The Assembly Rooms had a magnificent ballroom with parquet floor and a concert hall, fitted with stage and proscenium, which could seat 700 persons. This was used for concerts, amateur theatricals and public meetings. There was also a grill room, café, and billiard and smoking rooms. The modern photograph shows that the Assembly Rooms have now been replaced by a modern office building.

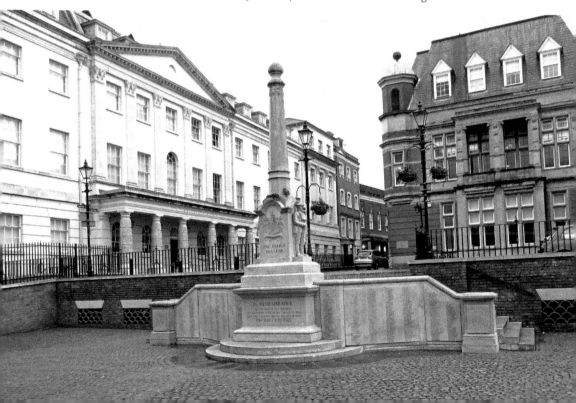

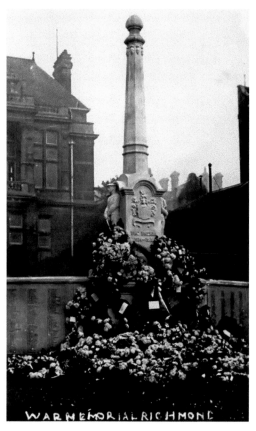

War Memorial, Richmond

The Richmond borough war memorial was unveiled by Field Marshal Sir William Robertson, Bart, GCB, GCMG, KCVO, DSO, and dedicated on Wednesday 23 November 1921, at 2.30 p.m. The memorial stands behind the old town hall facing the river and is bedecked with floral tributes on Remembrance Day. Sadly a family relative on my wife's side is listed amongst the names on this memorial.

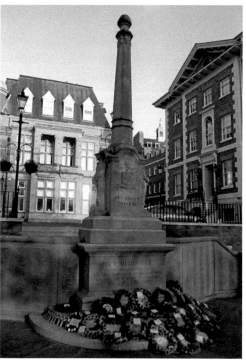

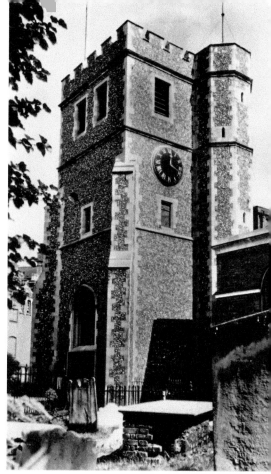

St Mary Magdalene Church, Richmond
The church dates back to at least 1339,
although this date could be earlier of course.
The church lies between George Street and
Paradise Road, and can be accessed via Church
Court. The tower to St Mary Magdalene dates
to 1507, although it was enlarged and repaired
in 1750. It has a battlemented top and has
been constructed of flints and stone. The
modern view shows that the tower remains
unchanged.

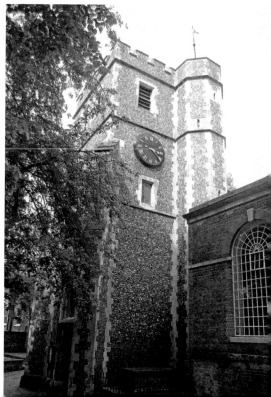

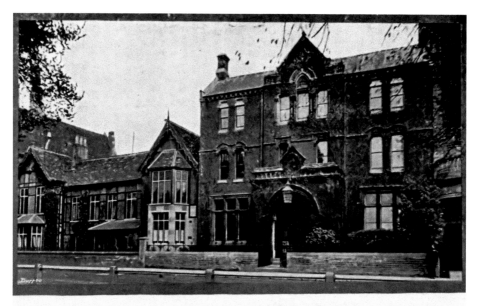

THE FREE LIBRARY AND MUSEUM, RICHMOND.

The Free Library and Museum, Richmond

The Richmond Free Library, situated on Little Green, was opened at 3.30 p.m. on Saturday 18 June 1881 by the Countess Russell. The building was designed by F. S. Brunton. Prior to this Mr Edward King, the founder of the *Richmond and Twickenham Times*, campaigned for a free public library in the late 1870s. Richmond was the first free public library in the London district, established under the Public Libraries Act. The librarian appointed was Mr Alfred Cotgreave, who within three months was issuing 350 books a day. The museum is currently situated in the old town hall building in Whittaker Avenue. The building left of the Library is The Cottage. The scene remains little changed today.

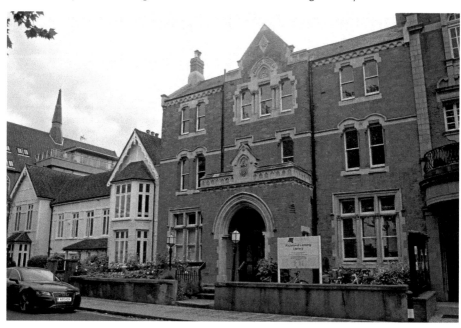

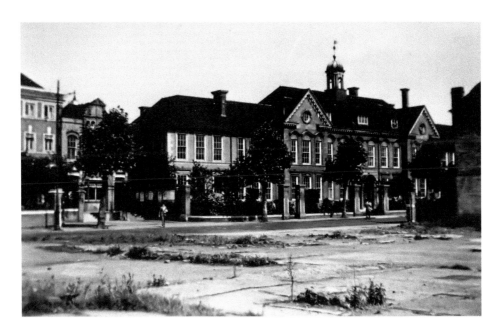

County School for Girls, Parkshott

The County School for Girls is seen here from an original photograph taken in the 1950s. The name of the land that this school was built on, Parkshott, is of interest, being of medieval origin, a shott denoting a strip of land. The foundation stone for the new County School for Girls was laid by Sir Philip Magnus on 4 April 1908. The architects were Messrs Jarvis and Richards. The building has three floors, and a long frontage with the main entrance in the centre. The site on which the school stands is approximately an acre and three quarters. The initial cost of the building and furnishings came to £14,000. Photographing the current view proved difficult as the original photographer had the advantage of a cleared building site on the opposite side of the road.

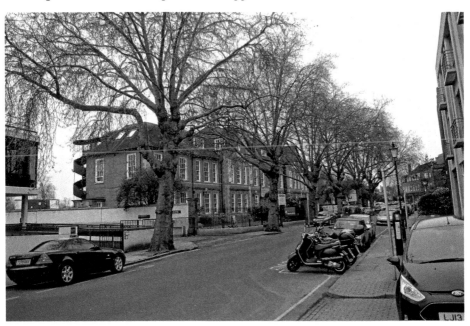

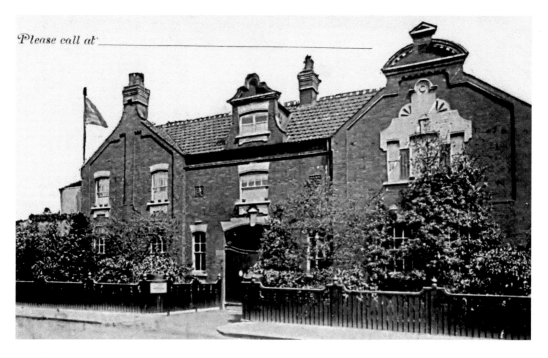

Please call at

Royal Sheen Laundry, Sheen Park

The Royal Sheen Laundry in Sheen Park is not to be confused with the other royal laundry in the Kew Foot Road (called the Prince Albert Modern Laundry, which catered for all the royal households' laundry). The laundry in Sheen Park was an elegant building with interesting architectural details, which unfortunately burnt down in 1909, causing £11,000 worth of damage. The fire gutted the building and completely destroyed the laundry. The manager and his family, who lived on site, had a narrow escape. In the modern photograph you will see that houses now occupy the site.

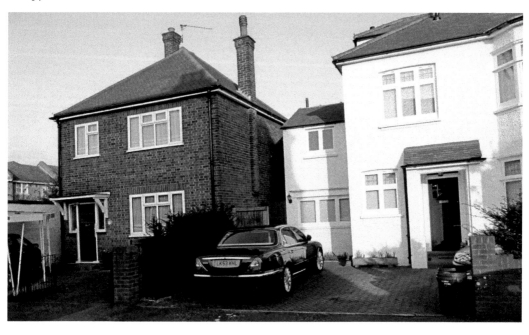

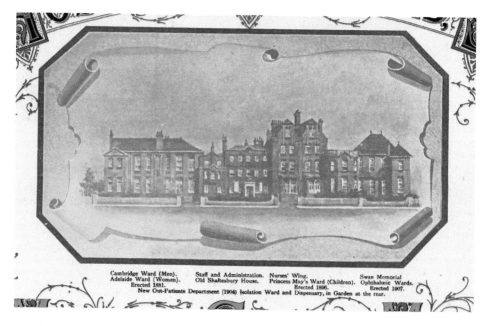

Cambridge Ward (Men). Staff and Administration. Nurses' Wing. Swan Memorial
Adelaide Ward (Women). Old Shaftesbury House. Princess May's Ward (Children). Ophthalmic Wards.
Erected 1881. Erected 1896. Erected 1907.
New Out-Patients Department (1904) Isolation Ward and Dispensary, in Garden at the rear.

Royal Hospital, Richmond

The Royal Hospital in Kew Foot Road was founded in 1863. The original house that formed the hospital was Rosedale Cottage, once the residence of James Thomson, the famous poet, who lived here between 1736 and 1748. The hospital was opened in 1868 by the Earl and Countess Russell. Queen Victoria consented to become patron of the hospital, and thus the title Royal Hospital was adopted. Many changes, too numerous to enumerate, have been made to the hospital in the intervening years.

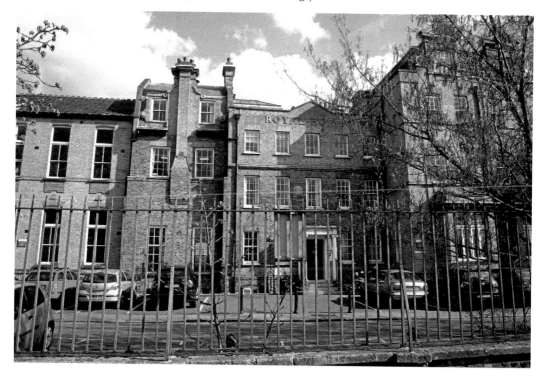

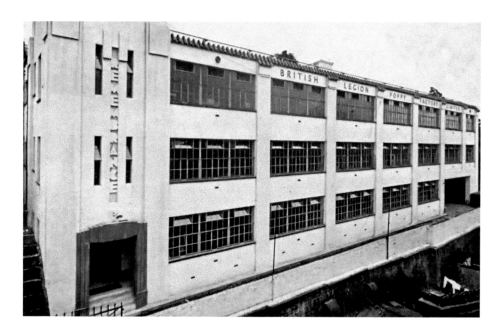

The British Legion Poppy Factory

The image shows the British Legion Poppy Factory in Petersham Road. The factory was opened in 1933 by HRH The Princess Royal. Prior to this, the first poppy factory in Richmond was housed in a converted brew house in 1926, when Cardigan House on Richmond Hill was purchased, to be adapted into a clubhouse and flats for the workers. The artificial flowers produced at the factory became a symbolic and permanent reminder of the ultimate sacrifice that our brave servicemen have undergone.

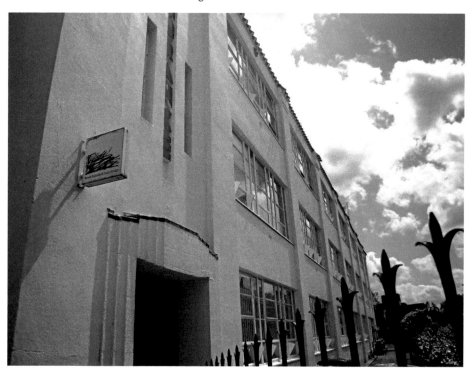

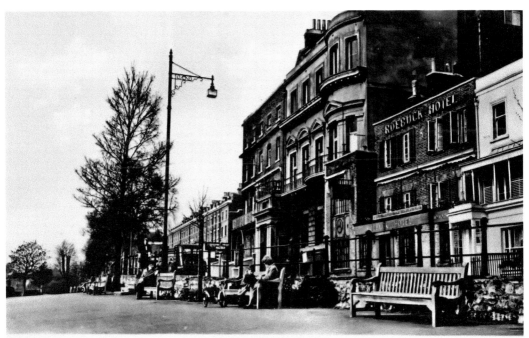

ES.14 THE TERRACE, RICHMOND.

The Terrace (Roebuck Hotel)

The Roebuck Hotel can be seen here photographed in the 1950s, standing in a commanding position along Richmond Hill by the Terrace. The landlord at this time (1951) was Mr Andrew Chivers. However, the Roebuck was first established in 1730. An advertisement dated 1910, when the proprietress was Mrs T. W. Macnee, describes the services thus: 'Very large and artistic Coffee Rooms filled with Pictures, Engravings and Sculpture, and affording accommodation for 250 people. Table d'Hote Luncheons and Dinners. Large and small parties catered for on the shortest notice.'

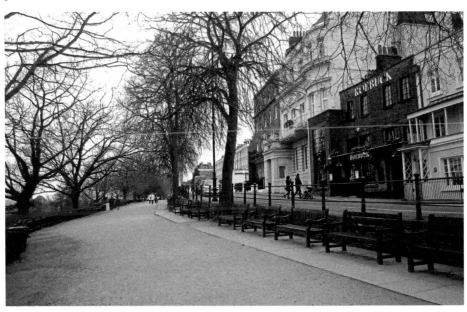

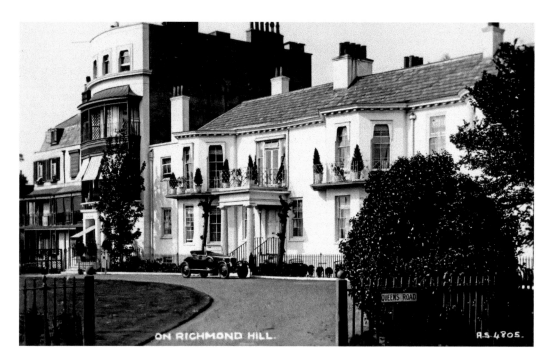

On Richmond Hill (Moreshead/Richmond Gate Hotel)

This hotel, now the Richmond Gate Hotel, stands at the top of Richmond Hill. Previously called the Morshead Hotel, it comprises a row of late eighteenth-century cottages, namely Stanley Cottage, Syon (or Sion) Cottage and Morshead House. Lady Morshead lived in the latter house and can be traced back as a resident on the Hill to 1825. Lady Morshead was renowned for her superb dinner parties and was a popular local figure. An advert for the Morshead dated 1905 describes it as, 'a charming recherché residence, close to the entrance to Richmond Park and convenient to the church, railway stations and river'.

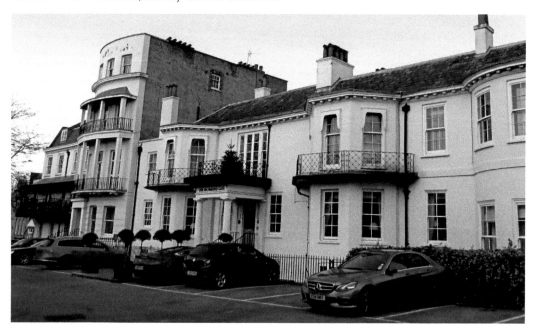

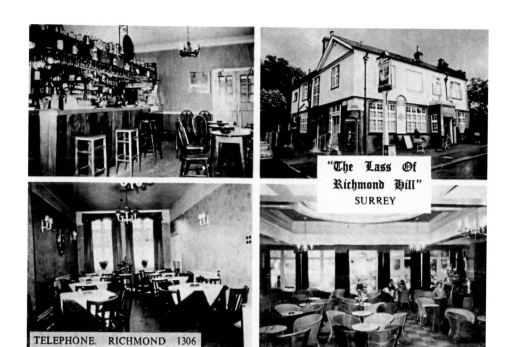

"The Lass Of Richmond Hill" SURREY

TELEPHONE. RICHMOND 1306

The Lass of Richmond Hill

This well-known public house stands near the top of Queen's Road. Although it claims to date to 1537, evidence can only be found for it reaching back to the 1850s (in Richmond rate-books). However, the Watney Mann brewer archives, which go back to 1796, mention an inn on this site dating to 1596, so this establishment could be much earlier than the rate-books suggest. Much debate also centres on the song 'The Lass of Richmond Hill' as to which town this refers to, Richmond, Yorkshire or Richmond, Surrey. Even if not correct, the name of this public house seems very apt for the area.

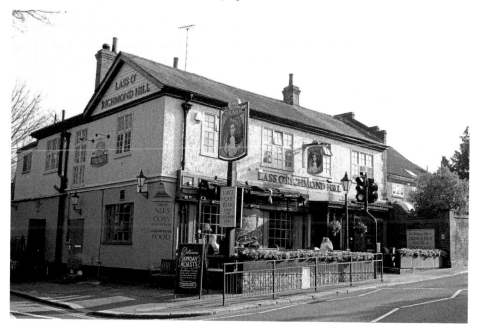

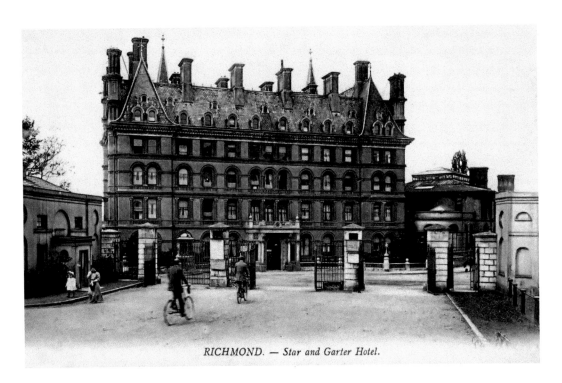

RICHMOND. — Star and Garter Hotel.

Star and Garter Hotel

The Star and Garter hotel seen here, from just beyond the main gates of Richmond Park, in 1910. The architect of this extraordinary building, executed in the French chateau style, was E. M. Barry and dates to 1864. There had been a much humbler inn on this site dating back to 1738. The Star and Garter is also famous for the fact that Charles Dickens used to take his friends to this establishment for celebrations. Dickens lived at one time in Elm Cottage in Petersham not far from the hotel. The current photograph shows the building designed by Sir Edwin Cooper in 1924 that replaced the former hotel.

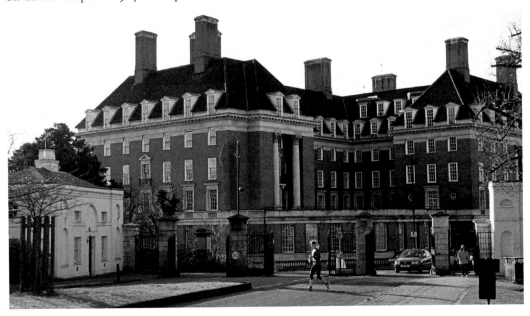

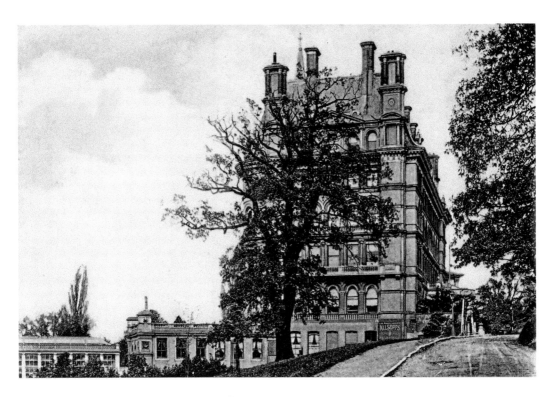

Star and Garter Hotel from the Hill

An unusual side view of the Star and Garter Hotel in 1905, taken from the Star and Garter Hill. The manager of the hotel at this period was Mr Charles James, who managed the hotel from 1894 until 1905. Towards the end of the Victorian era the hotel unfortunately suffered a decline in business. By 1915 it had been sold by auction for use as a hospital for paralysed soldiers. The building is currently being renovated.

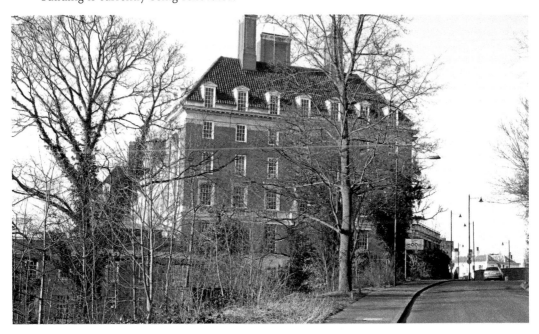

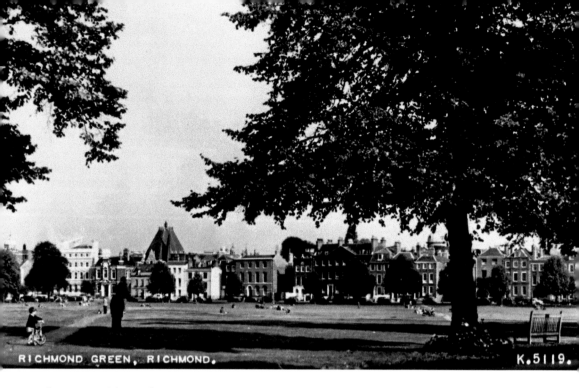

RICHMOND GREEN, RICHMOND. K.5119.

The Green, Richmond

The Green was originally the pleasure grounds of the Palace of Sheen and was considerably larger in size than it is today. In an early survey of 1650, it was said that The Green was twenty acres in size and had 113 elms planted on it. Although now reduced in size, it has been enjoyed by local inhabitants for recreational purposes right up to the present day. In the modern picture one can see that the skyline of buildings that flank The Green has changed, but that some of the buildings are still recognisable.

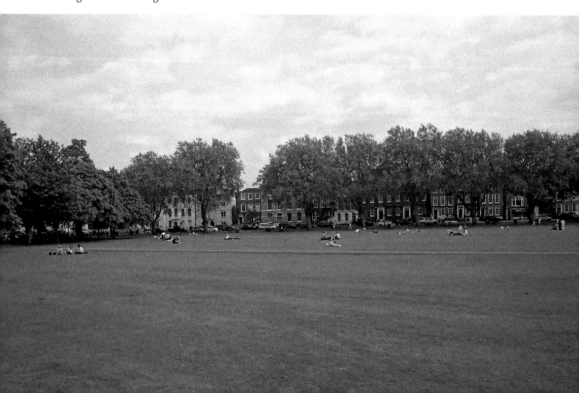

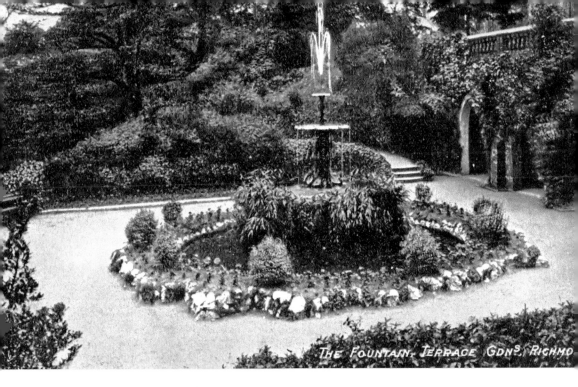

The Fountain, Terrace Gardens

This elegant ornamental fountain in Terrace Gardens remained until the Second World War, when it was replaced by a modern sculpture of a naked Aphrodite, nicknamed 'Bulbous Betty'. The sculpture had been exhibited at the Royal Academy and was carved by Allan Howes. This sculpture caused much controversy in the 1950s and was periodically vandalised during this period. However in annoyance to the faction that disliked the sculpture, it remains to this day a feature of the Terrace Gardens.

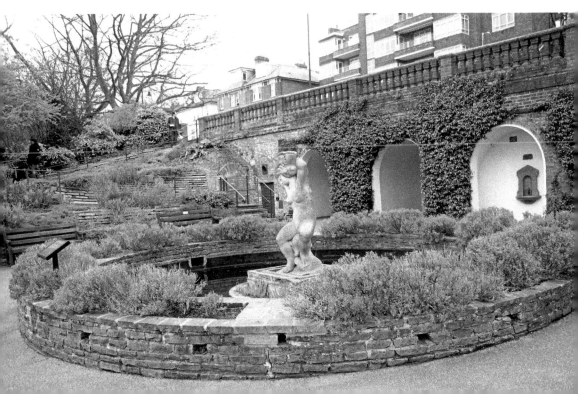

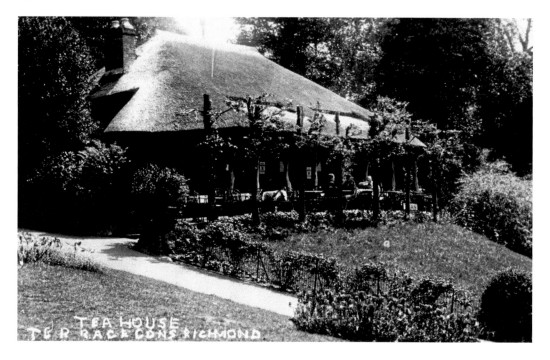

Tea House, Terrace Gardens, Richmond

The Tea House was formally a thatched cottage or summer house that stood in the grounds of Buccleugh House before it became Terrace Gardens. Terrace Gardens was opened to the public on 21 May 1887 by Princess Mary Adelaide, Duchess of Teck, and the Duke of Teck. The picture we see here is dated to 1930, and shows people enjoying tea and admiring the view from this elevated position; fine views of the Thames can be seen from this high vantage point. Not far from the Tea House stands the sculpture of *The River God* by John Bacon RA (1740–99).

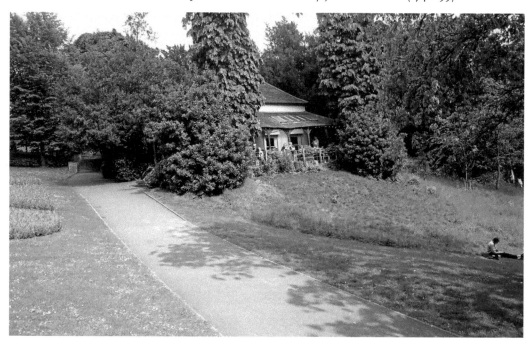

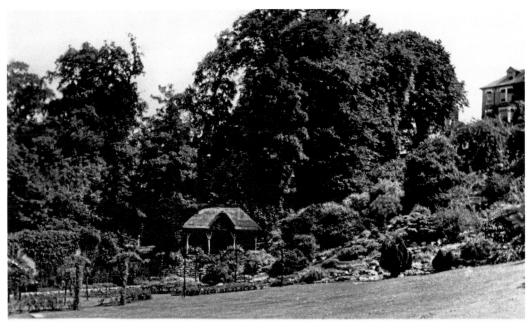

THE ROCKERY, TERRACE GARDENS, RICHMOND

The Rockery, Terrace Gardens, Richmond

On the right-hand side of the picture, gently rising up the slope of the hill, the rockery can be seen. Rockeries were very popular in the Victorian period and were a perfect backdrop for specimen plants. In the middle of the picture can be seen the summerhouse, which you will notice is different from the current wooden structure. A summerhouse has existed on this spot since 1936, and makes a good viewing point to the river below. To the left is the rose garden. The planting is different in the modern photograph, but both command an artful beauty.

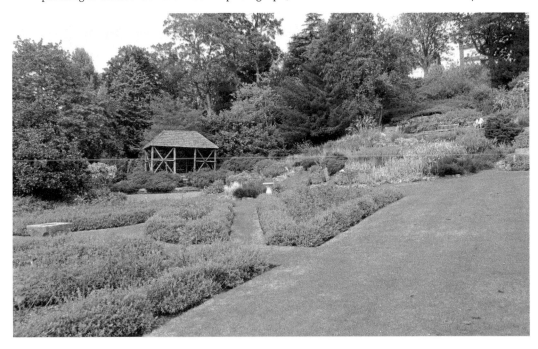

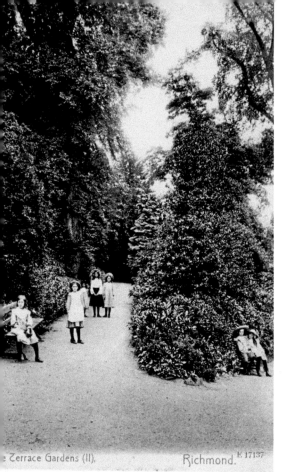

Terrace Gardens (II), Richmond. K 17137

The Terrace Gardens

Terrace Gardens was once known as Hill Common, and in the 1700s Lansdowne House was built on the upper extremities of what is now Terrace Gardens. Lansdowne House was eventually demolished and in 1887 became Terrace Gardens. If we look at the Edwardian view, just along the right-hand path past the two girls stood the former Richmond Wells. The entrance to this is quite impressive, more so even than the site of Epsom Wells, that now stands in the middle of a housing estate. The Richmond Wells entrance is lined with concrete casts of barrels, supposedly moulded from ones on the Cutty Sark, but even if this is a complete fabrication, they still make an extraordinary entrance to the wells.

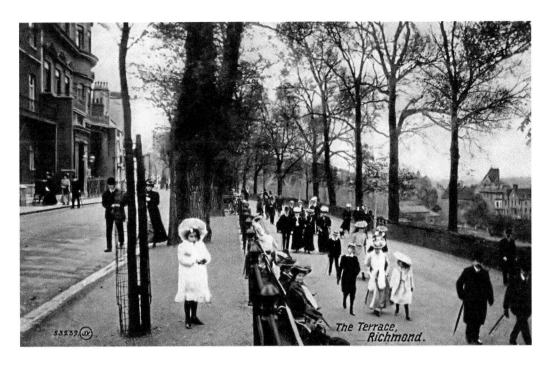

The Terrace, Richmond

This view of The Terrace from the Edwardian era shows what a popular place it was to promenade and admire the view of the river Thames. The spectacular view from The Terrace is world renowned, and on a clear day one can see as far as Windsor. The houses along The Terrace have had some very distinguished residents, both currently and in the past. For example, at No. 3 George III's card maker, Blanchard, once dwelt.

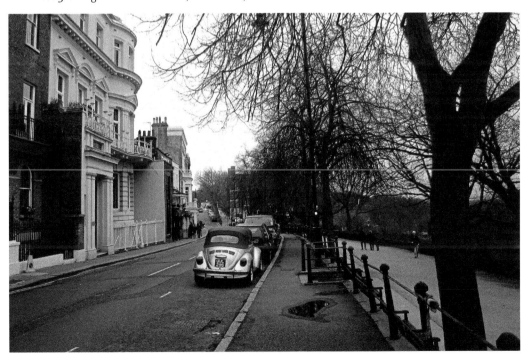

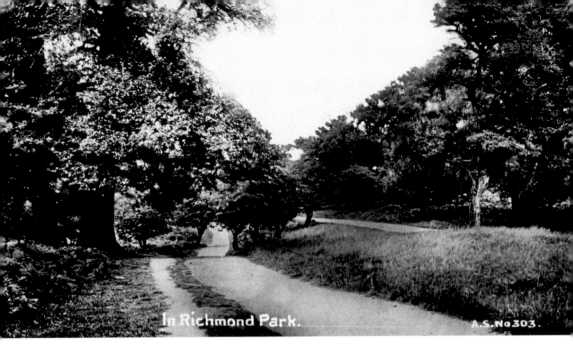

In Richmond Park. A.S. No 303.

In Richmond Park

Richmond Park is unusual in that it does not have tarmacked pedestrian paths, but earth trodden paths, so looks far more naturalistic. The park was originally known as New Park to differentiate it from the Old or Lower one, and dates back to Charles I's reign, when a wall encircled the park, being at that time primarily used by royalty for hunting. The famous case was when John Lewis, a Richmond brewer, took out an action against the Crown for free access through the park. Princess Amelia had restricted access. John Lewis successfully won the court case and free passage by pedestrians was granted. The views look similar, but far more vehicles now travel through the park.

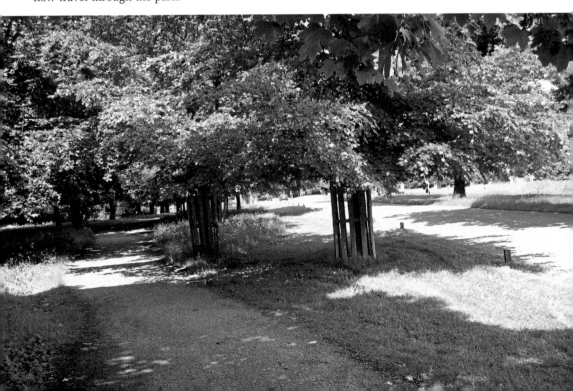

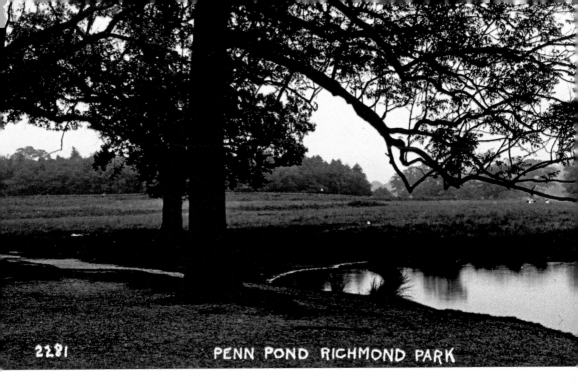

2281 PENN POND RICHMOND PARK

Pen Ponds, Richmond Park

The pen ponds, or penned ponds as they were originally called, are thought to date from the time of Princess Amelia (a daughter of George II). Enlargement took place of what are said to have originally been gravel pits to construct the ponds, the purpose of these ponds being to keep a large quantity of elvers (young eels) in. The two ponds together cover an area of seventeen acres. The pen ponds are a popular place for visitors to Richmond Park.

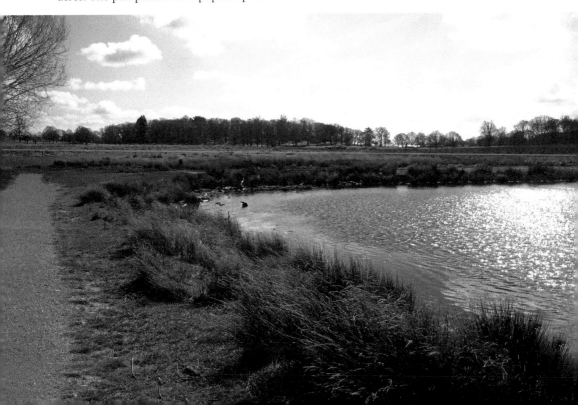

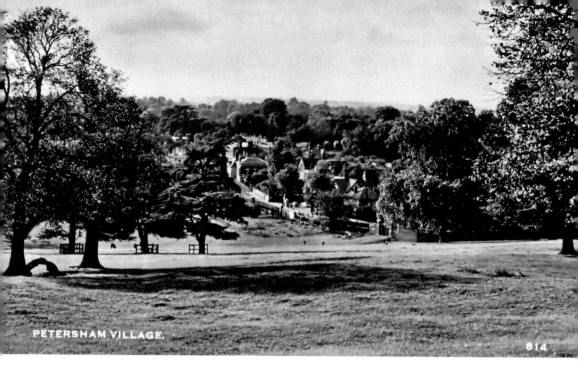

PETERSHAM VILLAGE.

614

Petersham Village

This view of Petersham village taken in 1958 shows part of the village from the elevated vantage point of the high ground in Richmond Park. The Dysart Arms, Petersham House and Rutland House can be seen on the right-hand side of the road, and on the left the chimneys on the roof of Montrose House can be seen. The oldest house in Petersham is Sudbrook House (out of view) dating to 1726. Petersham has some very distinguished Georgian houses and strong historical associations.

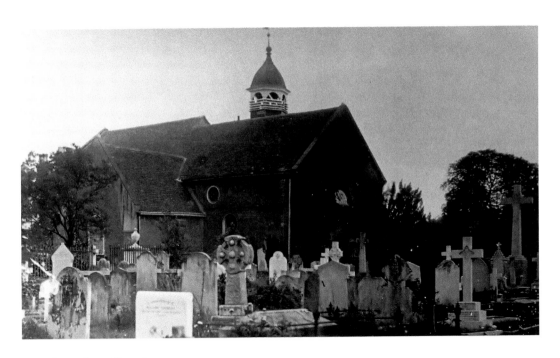

Petersham Church

This beautiful old church has a very venerable history; it has been purported that a church structure has stood on this site going back to the Norman Conquest. The oldest part of the present structure is said to date back to 1505. Many very distinguished persons have been buried in this churchyard, including Agnes and Mary Berry (literary friends of Horace Walpole), Mortimer Collins (poet and novelist), and Richard Crisp (the author of *Richmond and its Inhabitants from the Olden Times*). In the Edwardian view we can see the Celtic style cross near the centre of the picture; this belonged to Sir Arthur Sloggett (1857–1929). He had a very distinguished military career. Sloggett's grave has now been moved and faces in the opposite direction.

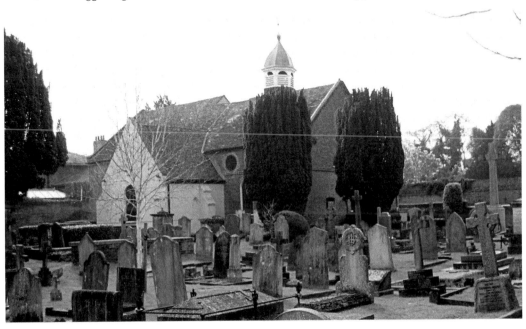

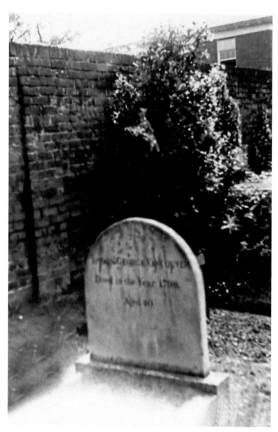

Captain George Vancouver's Grave

This image is taken from an original photograph from the 1950s of Captain George Vancouver's grave (1757–98), the famous navigator who charted and explored the coasts of British Columbia and Alaska. His grave, being of historical importance, is much visited, particularly by Canadians and Americans. There is a sign on the front wall of St Peter's church in Petersham directing visitors to its location. Vancouver lived in Glen Cottage along River Lane in Petersham, not far from the church. He died aged 40 on Thursday 10 May 1798 at the Star and Garter Hotel, also nearby. There is also a memorial inside the church to Vancouver, put up by the Hudson Bay Company in 1841. His grave was renovated in the 1960s. Notice the wreath bequeathed by Canada, laid respectfully on his grave in the modern photograph.

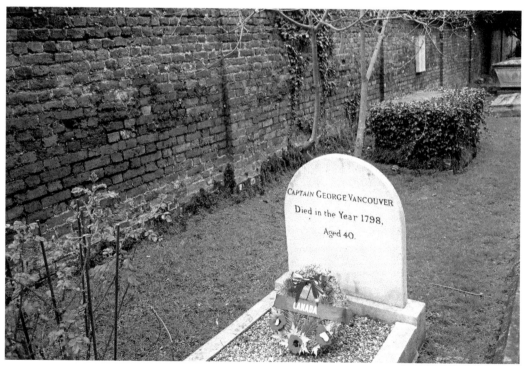

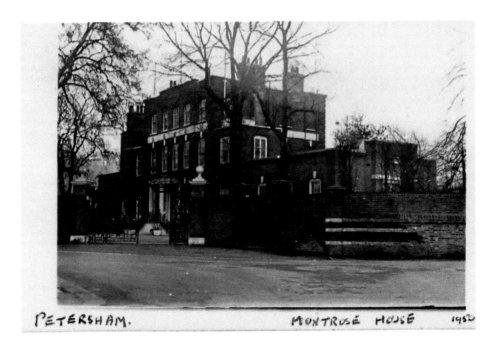

PETERSHAM. MONTROSE HOUSE 1950

Montrose House, Petersham Road

This house is probably one of the most prestigious in the whole of the Richmond area. It dates to the late seventeenth century, and is a Grade II listed house. Sir Thomas Jenner had the house built around 1670. The property was leased to the Dowager Duchess of Montrose in 1838, although it was first called Montrose House in 1859. Other notable tenants included Admiral Sir Joshua Rowley and his son, Sir Charles Rowley. Bartholomew Burton (former deputy governor of the Bank of England), General Sir William Moore, K. C. B. and Sir Philip Carr (Chairman of Peak Frean & Co Ltd). In more recent times Tommy Steele (a pop star of the late 1950s and early 1960s) lived in this house for almost thirty years.

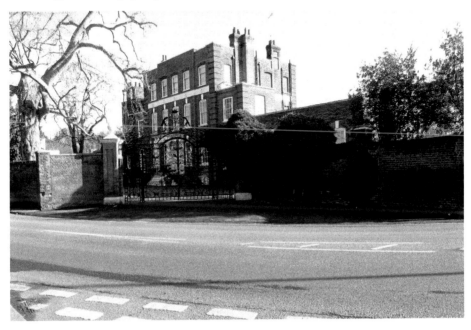

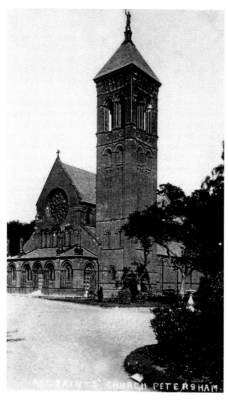

All Saints' Church, Petersham

All Saints' church was conceived by Mrs Warde as a memorial to her deceased father. The church was to be consecrated by the Bishop of the Diocese, but sadly never was, and is currently a private residence. The building itself is an architectural gem, built in the Byzantine style, and executed in a deep red terracotta. The architect was Mr John Kelly, and his firm Messrs Kelly and Dickie superintended the work. The church is located in the grounds of the former Bute House. It was thought that Petersham's population would expand and that this church would supersede the old parish church; fortunately this never happened, and St Peter's still remains the parish church.

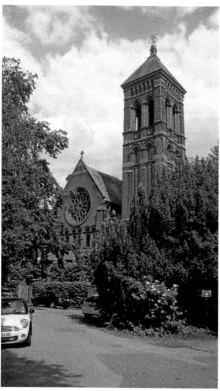

Ham Common (The New Inn)

This original photograph dating to 1932 shows Ham Common with the New Inn visible at the northern extremity of the common. There had been a previous inn on the same site, known as the White Hart, dating back to the 1670s. Around 1780 the inn changed its name from the New Inn to the Hobart Arms, almost certainly as the Hon. George Hobart resided in Ham. However, in 1822 the inn reverted back to being called the New Inn once again.

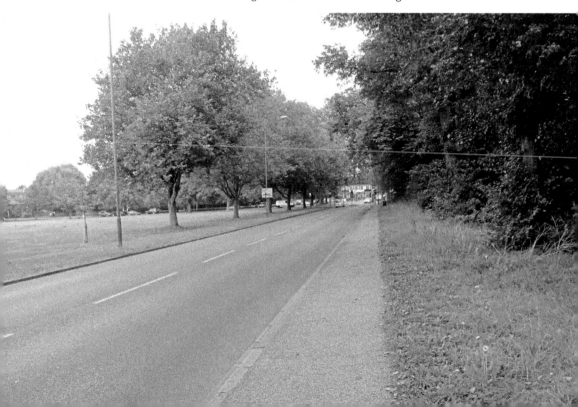

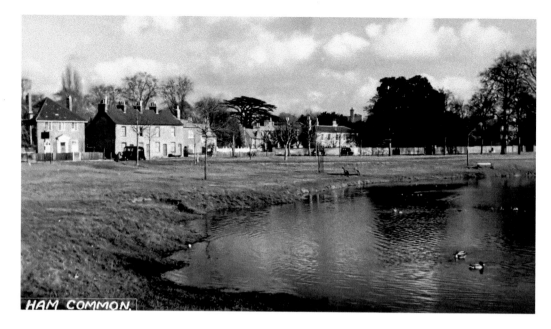

HAM COMMON.

Ham Common, the Pond

The pond on Ham Common lies in the western corner of the common, near to the centre of the village. As can be seen the pond is now a haven for wildlife. There was in fact another pond formed from a gravel pit, named after a distant relative, Neville. Sadly, Neville's Pond was used to throw rubbish in, so in 1858 was filled in. The common is dissected by the Ham Road and stretches eastwards as far as Richmond Park, this part of the common being far more densely wooded than the area to the west of the Ham Road.

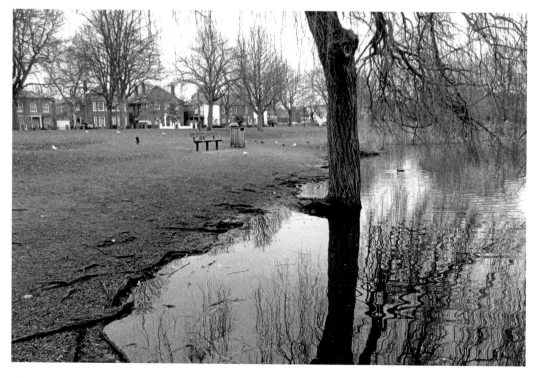

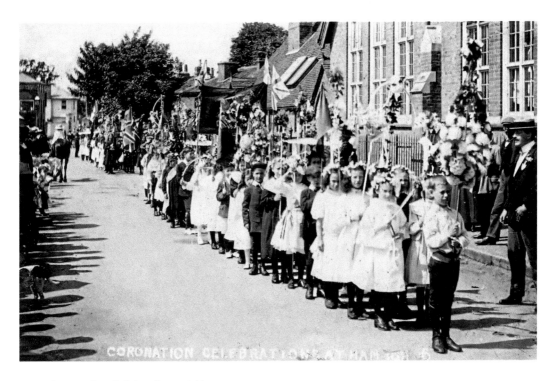

Coronation Celebrations at Ham, 1911

School children lined up outside the St Andrew's National School during the George V coronation celebrations in 1911. The building is now the Roman Catholic church of St Thomas Aquinas. The headmaster can be seen on the extreme right, and the floral tributes look extremely imposing. Richmond also contributed to the coronation celebrations. A fireworks display took place in the Old Deer Park, Richmond Bridge was illuminated (as were the boats) with thousands of coloured lights and Chinese lanterns, and there were also fire imitation naval engagements on the river between Richmond Railway Bridge and Petersham Island.

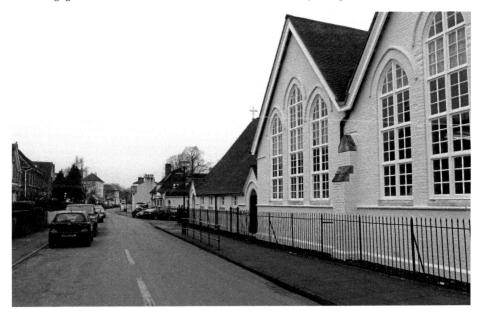

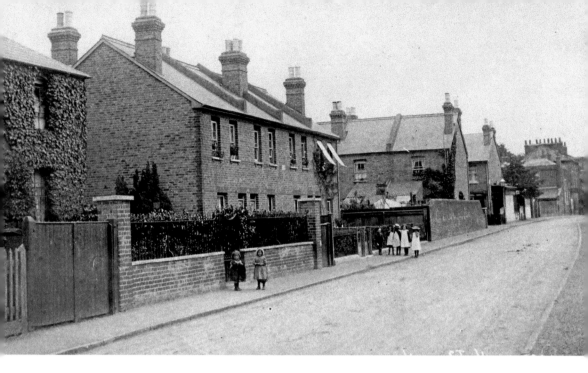

Ham Street, Ham

This Edwardian view is looking towards Ham Common. Ham Street runs from the common all the way to the Thames, being approximately three quarters of a mile long. Some fine eighteenth-century houses are positioned along Ham Street, the main one being the 'Manor House', the former residence of Sir Everard Home (1756–1832). Sir Everard was Sergeant Surgeon to George III. The famous architect Sir Gilbert G. Scott, RA (1811–78) also lived here in 1865. The other remarkable house is 'Grey Court', where Cardinal Newman spent his early childhood (now a school). Other noteworthy houses line Ham Street, such as Bench and Stokes House.

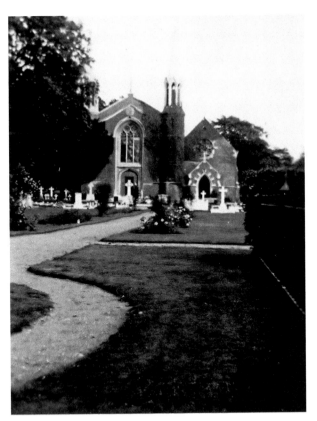

St Andrew's Church, Ham

St Andrew's church was built in 1831, the architect being Mr Edward Lapidge, and the builders were Messrs Joseph & Benjamin Butler of Chertsey. The first vicar of St Andrew's was the Reverend James Hough, MA (1831–47). There are some distinguished persons buried in the churchyard: Hyacinth Bowes-Lyon (sister of the Queen Mother, who died at Forbes house, Ham Common); Richard Owen (1804–92), superintendent of the Natural History Museum; and General William Eden (ancestor of Sir Anthony Eden), to name but a few.

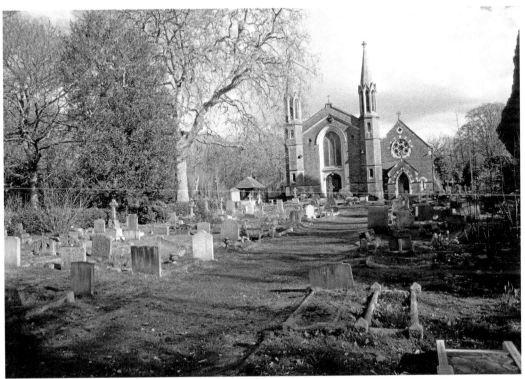

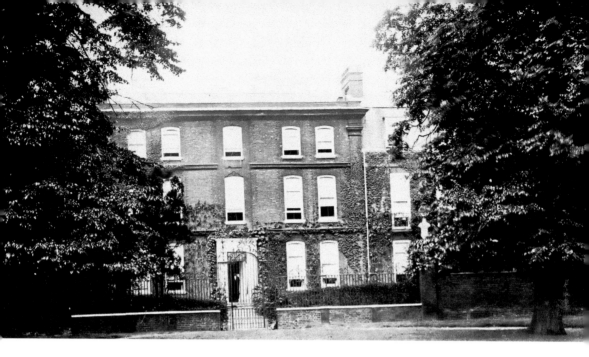

Ormeley Lodge, Ham

The picture shows Ormeley Lodge along Ham Gate Avenue, photographed in 1928, the mature trees partially obscuring the house. Ormeley Lodge was built *c.* 1716, the property being initially owned by Thomas Hamond. The wrought iron railings and gateway are of note, and has a fine Georgian door casing with carved decoration. The wings to the Lodge were added in the early nineteenth century. It has a long list of very distinguished owners. In 1949 the Lodge was purchased by Ronald A. Lee, an antique dealer who held an important loan exhibition at this house entitled 'Masterpieces of British Art & Craftsmanship'.

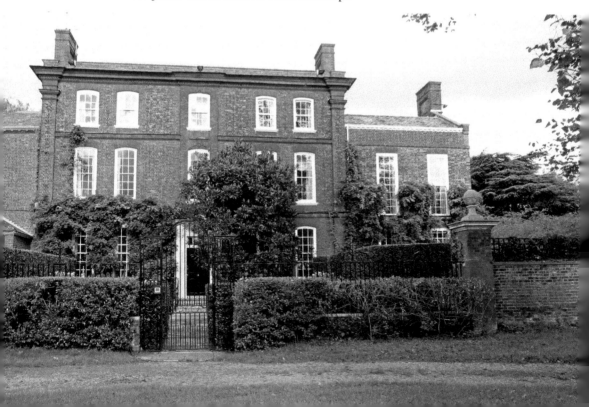

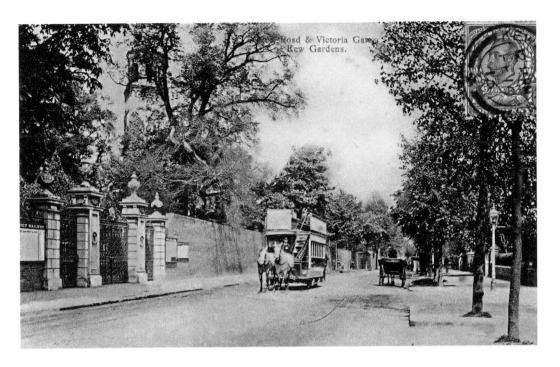

Kew Road and Victoria Gate, Kew Gardens

A horse-drawn tram can be seen in this picture, with the destination Richmond clearly visible on the side. This service operated from 1883 until 1912 and ran from Richmond to Kew Green. The impressive Victoria Gate, named after Queen Victoria, was opened in 1889 and designed by William Eden Nesfield. It is the nearest gate to Kew Gardens' railway station hence the notice regarding the District Railway. The modern photograph shows what an increase in vehicle traffic has taken place in the intervening years.

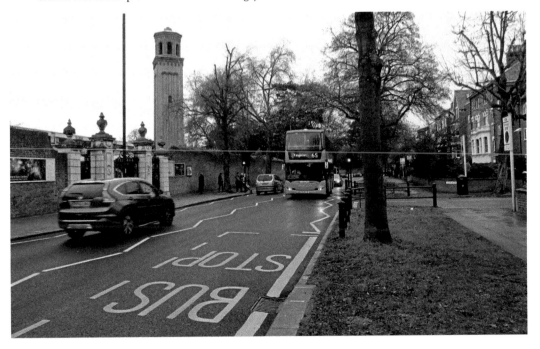

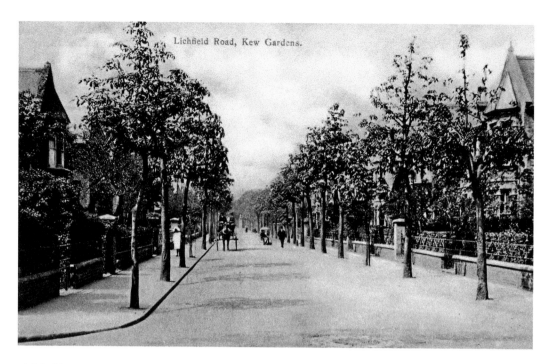

Lichfield Road, Kew Gardens.

Lichfield Road, Kew Gardens

Tree-lined Lichfield Road is pictured here in 1911, one of the gate piers to Victoria Gate of Kew Gardens can be seen in the distance. This road is the shortest route from Kew Gardens Station to Victoria Gate, and many visitors to the famous Kew Gardens must have trodden this route. Named after George Selwyn (1809–78), who was Bishop of Lichfield from 1867 to 1878, the road opened not long after his death. You will notice in the modern photograph how those trees have grown and partially obscured the view.

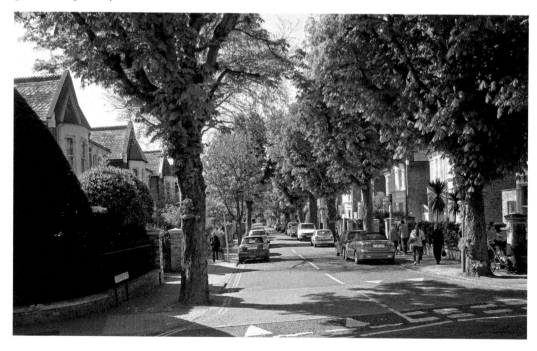

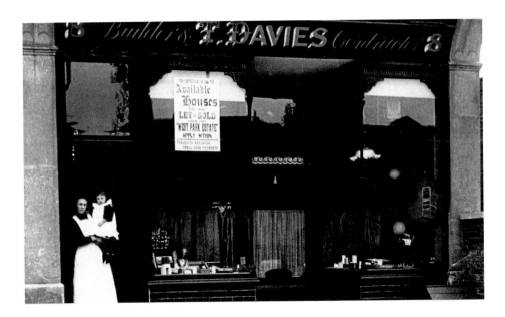

T. Davies Builder and Contractor

This shop in West Park Exchange lies on the other side of the pedestrian foot bridge from the entrance to Kew Gardens Station. Mr Thomas Davies first owned this shop in 1909 in partnership with Mr Aylett as a builder's workshop. In 1910 Mr Aylett is no longer in partnership, and Mr Davies is described as a builder and contractor (hence we can date this picture to 1910/11). In 1911 he still has this shop at No. 8, but he also has another establishment at No. 1, West Park Exchange, in which he is an estate agent. In 1912 he has formed a partnership with Mr Combridge, a builder, at No. 8, but they also have an estate agent at No. 1. By 1913 Mr Davies has gone and a Mr Henry Joseph Deathe, a fishmonger and poulterer, has taken over this establishment. There are still features in the modern shop that are recognisable from the earlier view.

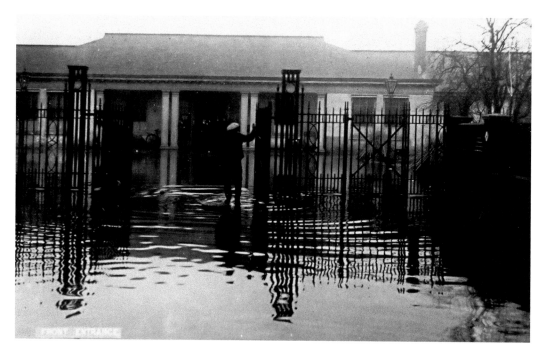

Front Entrance to Ministry of Labour Building, Ruskin Avenue, Kew

This dramatic view taken on 7 January 1928 shows the flooding caused by a huge storm surge; considerable damage to property resulted. The photograph was taken from Ruskin Avenue, which was laid out in 1905. By 1917 the Ministry of Labour building (Claims and Records Office) was functioning. The office closed shortly after the outbreak of the Second World War. The building was used from 1942 to 1944 by a topographical battalion to make maps for the D-Day invasion of France. In 1945–46 the site was used as a POW camp for Italian prisoners. The Public Record Office was opened in 1977 and renamed the National Archives in 2003.

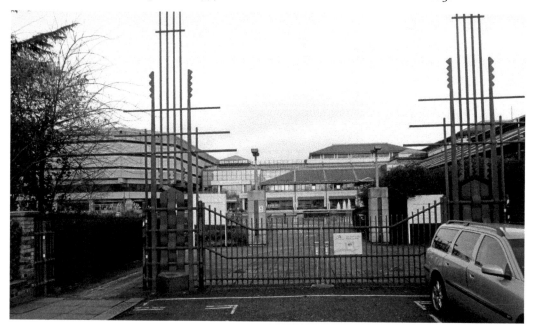

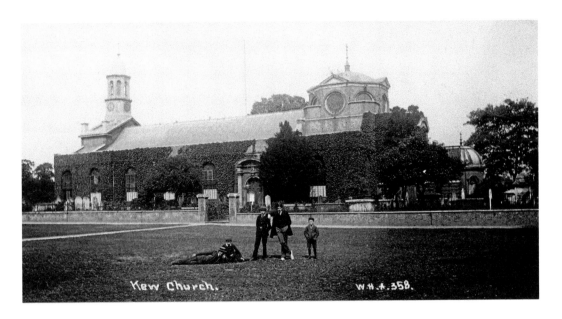

Kew Church

The original chapel on Kew Green can be dated to 1522, at first a private chapel of Thomas Byrkis and his family. However in 1710 Queen Anne donated a piece of land 100 feet square, and contributed £100 towards the overall cost of the chapel of ease to Kingston parish; Kew was part of the parish of Kingston. The chapel was consecrated on 12 May 1714 by the Bishop of Winchester. In 1770 the chapel was enlarged by Joshua Kirby (1716–74). Apart from the Royal patronage that this church has fortunately received, it has some extremely distinguished monuments, notably to Thomas Gainsborough (1727–88), the eminent artist, and to Sir William Hooker (1775–1865), former superintendent of Kew Gardens. The church has been extended and altered over time. The view clearly shows the Neo-Byzantine architectural style of the building.

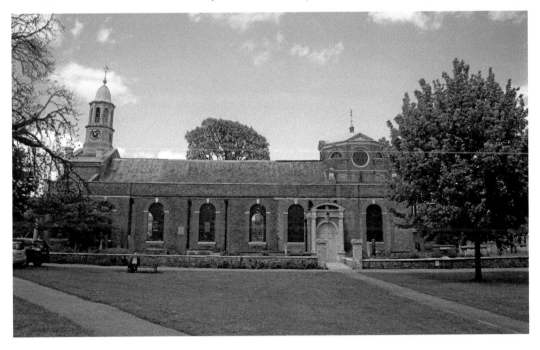

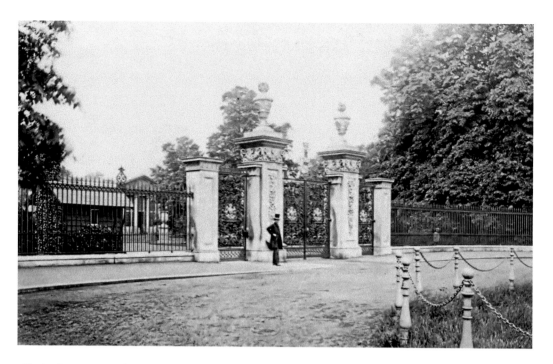

Elizabeth Gate, Royal Botanic Gardens, Kew

This image of the Main Gate to the Royal Botanic Gardens at Kew came from an original Victorian photograph. The Main Gates on Kew Green was opened in April 1846 and was designed by Decimus Burton (1800–81). He also designed the Palm House, Temperate House and Water Lily House. The wrought iron gates were made by John Walker. The Portland stone piers are decorated appropriately with floral designs and were carved by John Henning the Younger (1801–57). Not far from the gate (now renamed the Elizabeth Gate) on the south side of Kew Green can be found a plaque marking the site of the original and much plainer entrance dating to 1825.

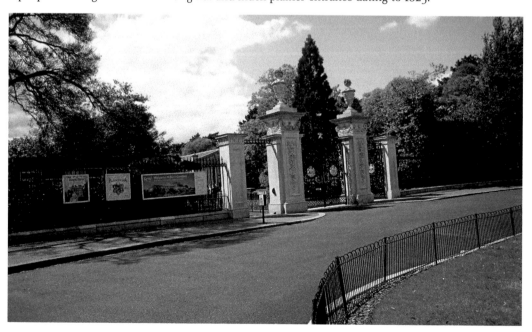

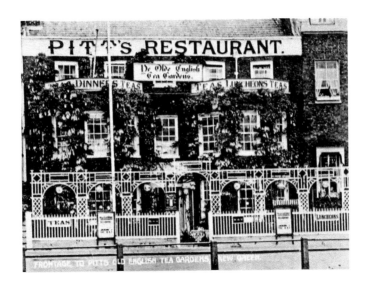

Pitt's Restaurant

Pitt's Restaurant photographed here in the Edwardian era was owned by Richard Pitt. He was born about 1851 in St Germans in Cornwall and married Rosa Augusta in 1883. He owned Ada Villa, where he had his restaurant, and Ivy House next door, presumably his residence. These two houses are on the northern side of Kew Green, not far from the Herbarium. In the Edwardian era there were a number of eating establishments along this road, catering for the visitors to the Royal Botanical Gardens.

Ada Villa is a mid-eighteenth-century brown brick establishment with three-window splayed bays on either side of the door, which has Tuscan columns either side of the door case. Ivy House, in yellow brick to the right of the restaurant, dates to the eighteenth century and was owned at one time by Thomas Howlett Warren. The most remarkable thing about the Edwardian image is the intricate eye-catching trellis work, which would have helped attract prospective clients to this eating establishment. The trellis work has now gone and the building is now fully revealed.

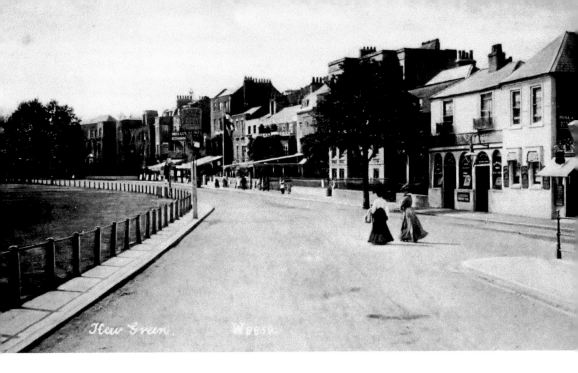

Kew Green

This picture shows Kew Green close to Kew Bridge in 1911. The Rose and Crown public house seen on the right-hand side was originally built in the 1730s. The current building dates to 1929 and is embellished in a Tudor style. A restaurant and tea establishment can be seen further along the road (see Pitt's Restaurant on previous page). In the modern photograph it will be noticed that the Rose and Crown public house has now been re-named 'Cricketers'.

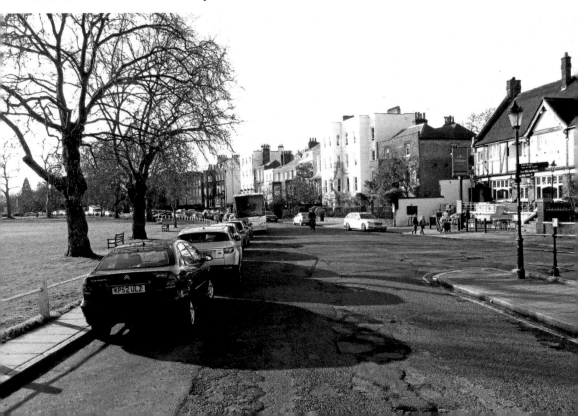

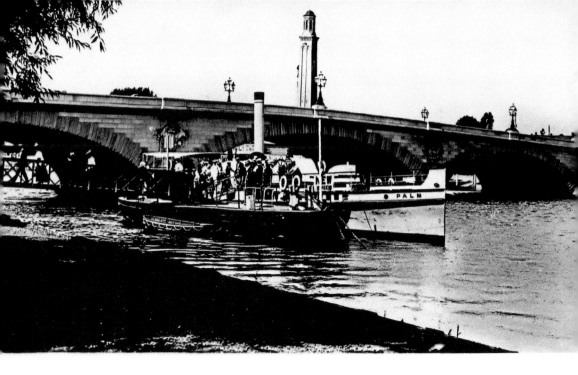

King Edward VII Bridge, Kew

The King Edward VII Bridge at Kew dates to 1903 and was designed by John Wolfe Barry and built primarily of Cornish granite. It was the third road bridge, the second bridge being by James Paine (who designed Richmond Bridge). The current bridge is very functional, having to deal with vast quantities of traffic. The tower of Kew pumping station can be seen in the middle of the picture. In the modern photograph note how the trees have grown up all along the river bank making it difficult to find a clear view of the bridge.

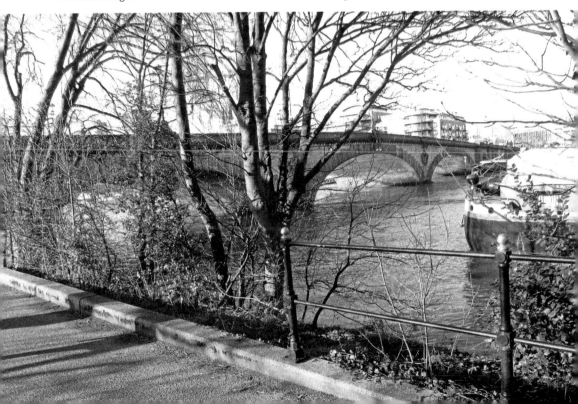

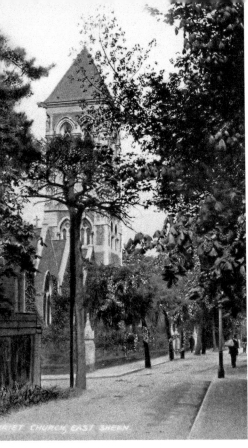

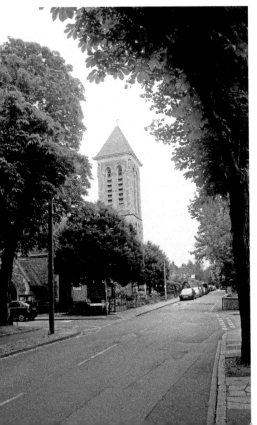

Christ Church, East Sheen

Christ Church in East Sheen was designed by the architect Sir Arthur Blomfield (1829–99), who lived not far away in Fife Road at 'The Cottage'. This church was one of his earliest works and he went on to design many more churches. The consecration of this church was due to take place in April 1863 but the tower collapsed, so had to be rebuilt. Therefore the church was not consecrated until January 1864 by the Bishop of London, Dr A. C. Tait. The view looks remarkably similar today.

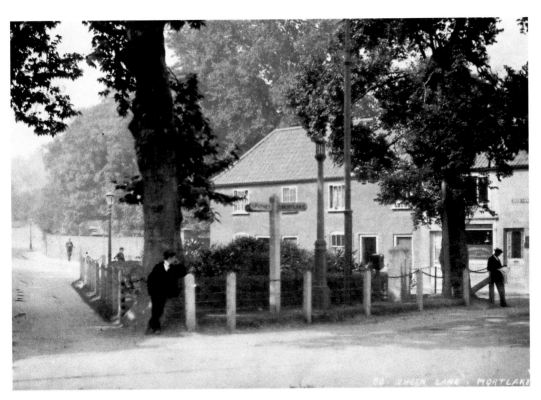

Sheen Lane

The Edwardian image of Milestone Green, sometimes called 'The Triangle', is viewed from the Upper Richmond Road, looking along Sheen Lane. Only the milestone, dating to 1751, remains, the white posts and chains having long gone. The buildings to the right were the Colston's Almshouses; these were built in 1707 and demolished in 1922 due to road widening. A war memorial in the shape of an obelisk can be seen in the modern view, dating to 1925. What was a charming peaceful area is now sadly just part of the urban landscape.

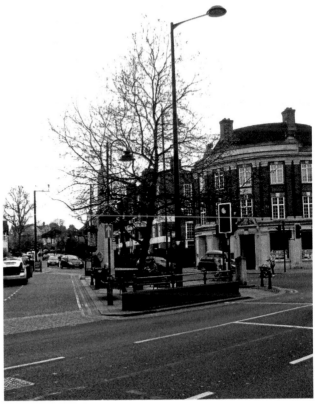

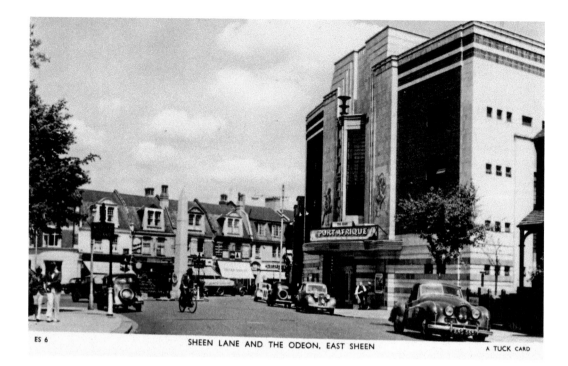

ES 6 SHEEN LANE AND THE ODEON, EAST SHEEN A TUCK CARD

Sheen Lane and the Odeon, East Sheen

This card can be dated accurately, as the film *Port Afrique* was shown in 1956. The Odeon cinema in Sheen Lane near the junction with the Upper Richmond Road existed from 1944 until 1961. Prior to this the cinema had been the Empire and before that the Sheen Kinema, which opened in 1930. However, there had been an even earlier cinema on this site called the Picturedrome which dated to 1910. Prior to this there had been an old house called The Larches, at one time occupied by Sir William Henry White. The current photograph shows Parkway House which has now replaced the cinema.

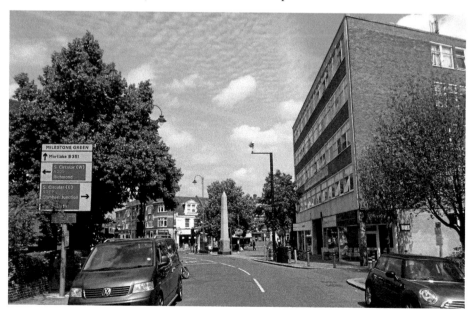

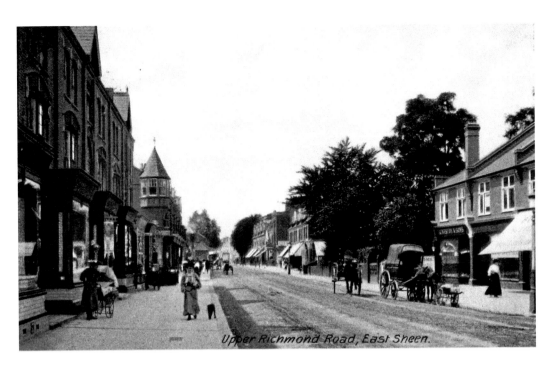

Upper Richmond Road, East Sheen.

Upper Richmond Road, East Sheen

A scene which dates to 1907 and shows people strolling along the Upper Richmond Road in East Sheen. The shop on the right (between Thornton Road and Portman Avenue) by the horse-drawn vehicle was owned by G. Weston & Sons and was an electrical engineers, the shop next to this was a bakers, owned by W. Glover & Son. The private residence next to Weston's was called The Chestnuts, and was owned by Mr John George Cathie. A tea shop and dairy can be seen on the other side of the road, and the side road just before the tower structure is Palewell Park.

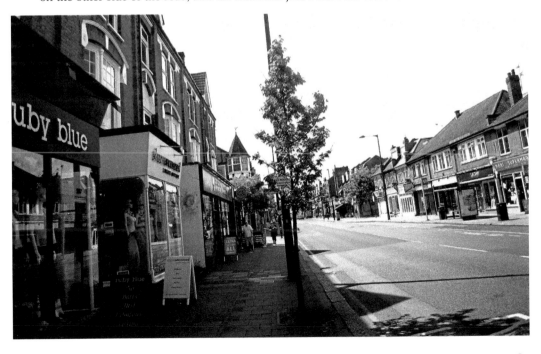

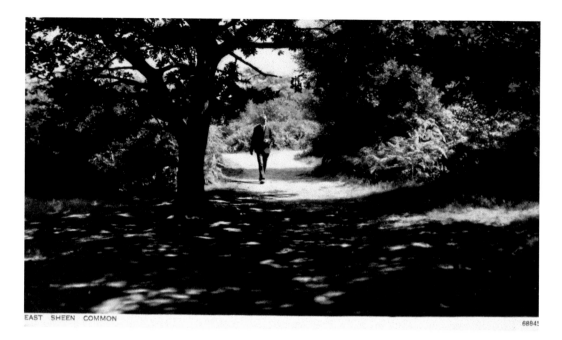

EAST SHEEN COMMON

68845

East Sheen Common

East Sheen Common covers an area of approximately fifty-three acres, although it has shrunk in size, as a survey in 1811 records that it was sixty-six acres in extent. Its survival is remarkable, in that it was not incorporated by Charles I into New Park (now Richmond Park) which so easily could have happened. The common is also a rare survivor of Surrey heathland; one can only hope that this remains so.

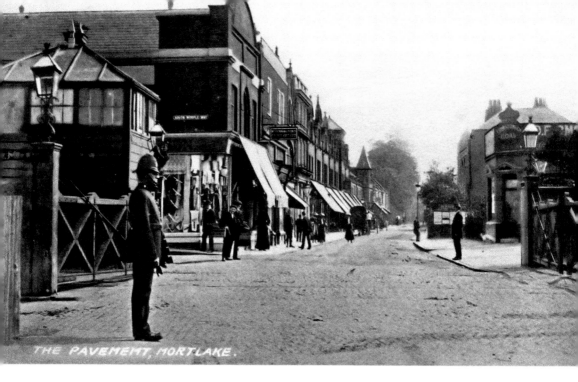

THE PAVEMENT, MORTLAKE.

The Pavement, Mortlake

The railway first came to Mortlake on 27 July 1846, initially served by the London and South Western Railway. Although the level crossing gates are annoying in that they hold up traffic passing along Sheen Lane, the surprising benefit of having the railway line bifurcate Mortlake is that it has preserved the ancient paths and worples. South Worple Way can be seen on the left beyond the level crossing. Also many paths are to be found on the northern side of the track. Many of these paths have origins going back to the medieval period where they skirted the fields.

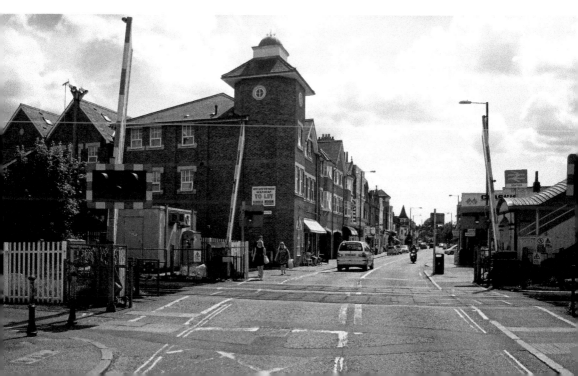

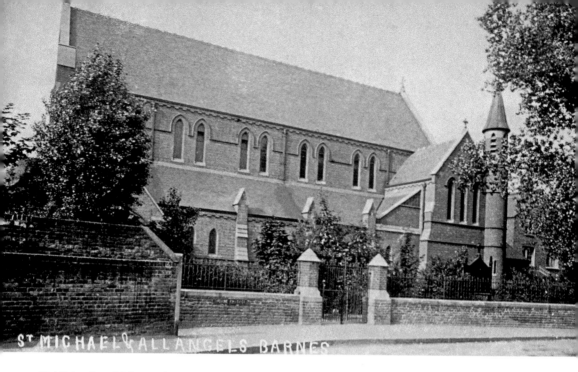

St Michael & All Angels Barnes

St Michael and All Angels, Barnes

This image shows the south front of St Michael & All Angels church from Charles Street. The original view was photographed in 1915. St Michael's initially started as an Anglo Catholic (now generally known as Catholic Anglican) mission church in Westfield's in 1877. However, building started in 1892 (and was subsequently opened in 1893) of the present church. The first vicar was the Reverend Bernard Kitson, who was vicar from 1919 until 1937. The current photograph shows the re-landscaping of the Charles Street frontage and new wall that has changed the appearance of the church from this view point.

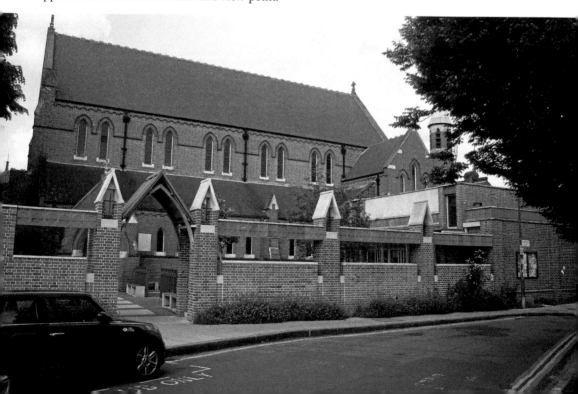

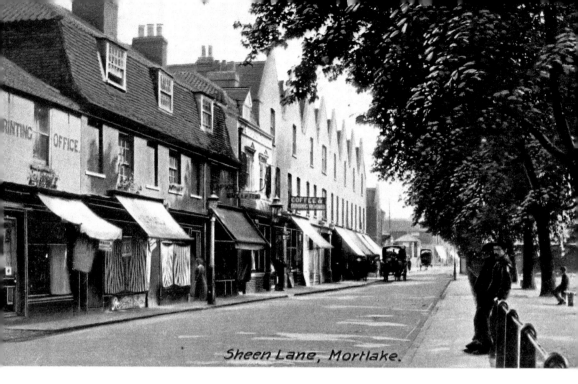

Sheen Lane, Mortlake.

Sheen Lane, Mortlake

An interesting variety of shops can be seen here in Sheen Lane, looking towards the level crossing, around 1906. The printing office on the far left was owned by Mr Herbert George Morris. Next to this was a confectioner, a tailor, and a boot maker. The public house with the ornamental lamp above was the Railway Tavern, listed at this period as a beer retailer; it was owned by Mr Ernest Cole. It had formerly been a private house dating *c.* 1800. Around 1810, Mr Rook, a boot maker, carried out his business from this house. The houses have now been demolished on the left up to the Railway Tavern.

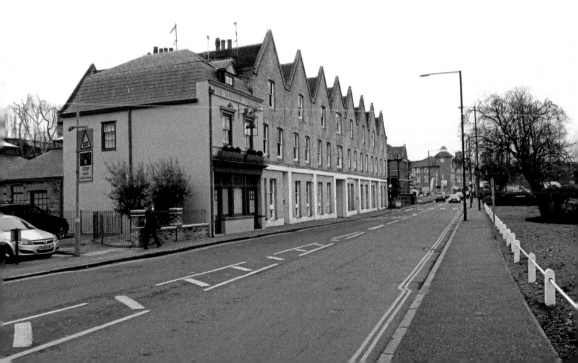

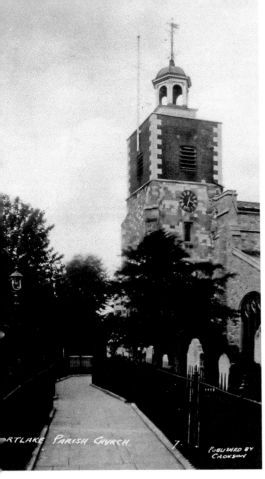

Mortlake Parish Church

The present church of St Mary the Virgin in Mortlake dates to 1543, but there had been a previous church standing on the site of what is now the brewery dating back to the fourteenth century. The church tower seen here is the only part of the original Tudor building that still stands, and has a most eye-catching cupola on its summit. The church font is noteworthy as it dates to the fifteenth century. Also of historical interest is the stone archway that can be seen in the churchyard, a surviving piece of the old medieval building. A plaque to Dr John Dee can also be seen inside the church. Sadly the trees now obscure the modern view of the tower. John Dee (1527–1608) was a famous astrologer and mathematician. Queen Elizabeth I famously consulted him.

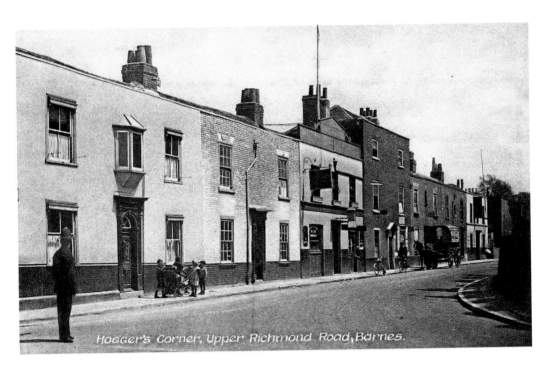

Hogger's Corner, Upper Richmond Road, Barnes.

Hogger's Corner, Upper Richmond Road, Barnes

Hogger's Corner was named after Samuel Hogger who owned a wheelwrights and motor works on this corner, which was actually part of the Upper Richmond Road, in the area known as Priest's Bridge. The public house in the centre of the picture was the Market Gardener, the first landlord being Mr Penston (1860–63). The pub closed in 1998 and was demolished in 2000. The house to the left of the pub was at one time a cart and wheel works. In regard to the modern photograph it will be noted that some of the buildings are still recognisable.

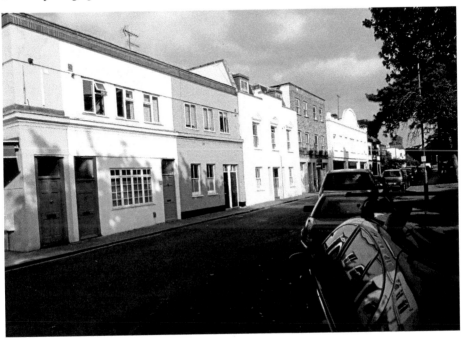

ATION ROAD, BARNES. 43682.

Station Road, Barnes
The coming of the railway to Barnes in 1846 gradually changed the area entirely from a predominantly rural to an urban environment. Research suggests that this section of Station Road was initially formed by carriages taking a short cut from Barnes station to the village. The part of Station Road near to Barnes Green has existed from the Tudor period. City commuters quickly snapped up the properties within easy walking distance of the station. The road retains its rural identity up to the present day.

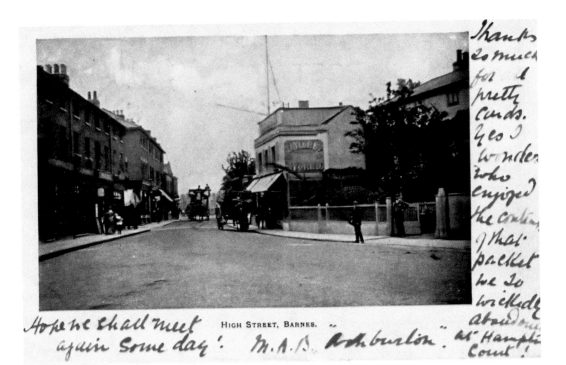

HIGH STREET, BARNES.

High Street, Barnes

The High Street, Barnes pictured *c.* 1903, showing the diverse type of shops at this period. The prominent building on the right was Taylor Brothers, a greengrocers and florists. Across the road on the left-hand side at No. 3 was Joseph Burns, a watchmaker. At No. 4 was Elders, a stationer. Next came the chemist Arthur Gray, followed by Teetgen & Co. Ltd, a tea and coffee merchants. In the modern photo you will see that all the old shops have gone and modern buildings have replaced the old, even the curve to the road has been straightened, making it difficult to recognise.

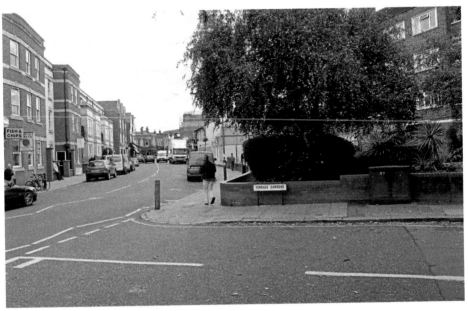

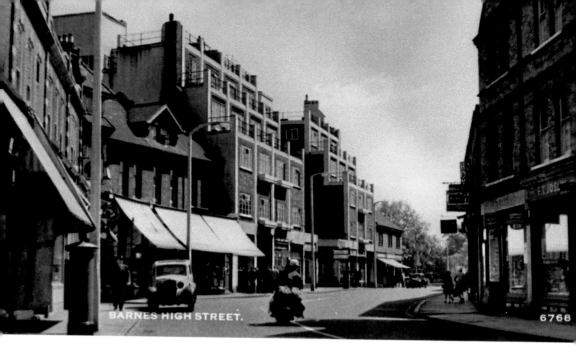

BARNES HIGH STREET.

6768

Barnes High Street

We see here the section of Barnes High Street looking towards Church Road. The most striking architectural feature is the block of thirty-six flats called Seaforth Lodge, designed in a stepped frontage over six shops. The plans for these flats date to 1936 and were completed by the late 1930s, the architect being E. H. Wale. These flats still look strikingly modern today; the shops themselves however have all changed.

ESSEX LODGE AND BARNES GREEN.

Essex Lodge and Barnes Green

Essex Lodge is the mock Tudor building in the centre of the image. The Lodge dates to around 1911, so is not as old as it purports to be, but is in keeping with the surrounding area. However, Essex House to the left of the Lodge does have historical interest, in that it is supposed to stand on the site of the Earl of Essex's house; he married the widow of Sir Philip Sydney, daughter of Sir Francis Walsingham. Essex House is now a surgery and Essex Lodge is now owned by Laurent Residential Property Consultants.

"THE GRANGE," CHURCH ROAD, BARNES, S.W.

The Grange, No. 54 Church Road, Barnes SW13

It is very rare to get an image of a house that also tells you details regarding the owner. This imposing house is situated on the corner of Church Road and the junction of Grange Road. William Goodwin Julian (mentioned in the text on the right-hand side) was born in 1873 and died in 1961. In 1901 he was described as a carpenter and joiner residing at Gloucester Street, St George Hanover Square. In 1911 he was a furniture dealer, twice married and had three children from his second marriage. It can be seen here what a delightful Georgian property Mr Julian owned. The view is still recognisable, the only difference being the metal archway over the entrance gate, and lack of posts surrounding the small island in front of the house.

Barnes Church

This image of the church comes from an original Victorian photograph taken by a local studio. The church is dedicated to St Mary and has very ancient origins, believed to go back to the early thirteenth century. Unfortunately many alterations have been made to the church, so little of the original structure remains. The tower is thought to date to the fifteenth century. The church was greatly enlarged in 1787.

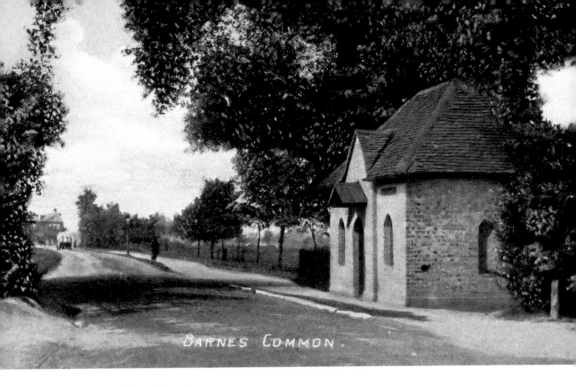

BARNES COMMON.

Barnes Common (Gate House)
This view shows the Gate House looking along Mill Hill Road, towards Rocks Lane in Barnes. Originally there had been a gate between Barnes and Putney Common to keep the cattle from straying. This effectively stopped animals roaming from one parish into another. The Gatekeepers' house can be traced back to the eighteenth century, so is a rare survivor. The current photograph shows how much more densely wooded this area is now than it was in the Edwardian era.

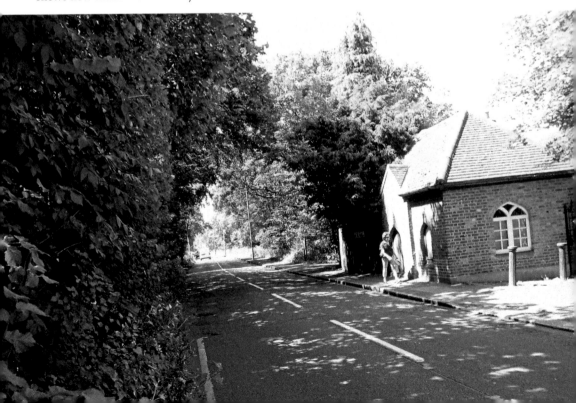

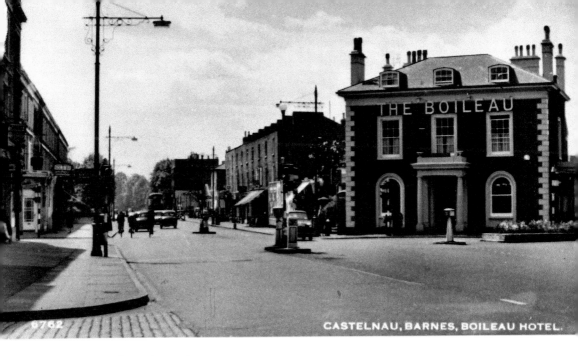

Boileau Hotel, Castlenau, Barnes

The Boileau Hotel is situated at the junction of Castlenau and Lonsdale Road and is the most northerly view represented in this book. The Boileau Arms Tavern, as it was originally called, was built in 1842. Named after Major Charles Lestock Boileau, who was responsible for developing an extensive part of north Barnes, it changed its name to The Old Rangoon and in turn was taken over by Bass Taverns in 1995. In more recent times it has been a restaurant and is now unoccupied awaiting development.

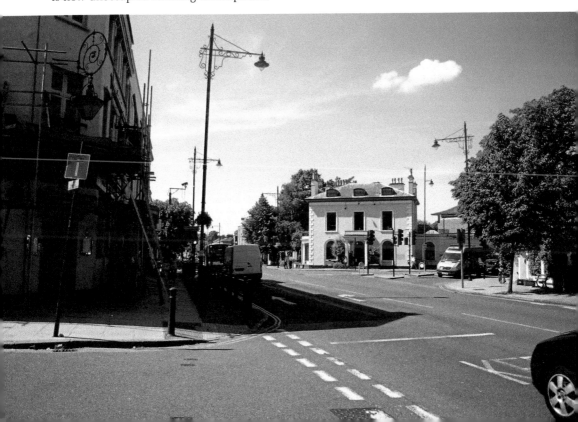

Acknowledgements

Grateful thanks for invaluable help go to all the staff at Richmond Local Studies, particularly to Jane, Felix and Patricia.

I would also like to thank Jo Chambers, Philip Edney, Charles Jobson, Tasmin Lang and Dr Jonathan Oates for their help and support.

This book is dedicated to Charles Jobson.